1979

**Graphic Effects by Photography**

Croy # Graphic Effects by Photography

translated by
F. Bradley

Focal Press, *London and New York*

© 1973 FOCAL PRESS LIMITED

ISBN 0 240 50832 7

Translated from Photos helfen zeichnen
© Verlag Karl Thiemig KG.
München,
West Germany

First edition 1973
Second impression 1978

Filmset by BAS Printers Limited, Wallop, Hampshire
Printed and bound by A. Wheaton & Co. Ltd, Exeter

# Contents

The photograph has long occupied an
assured place in commercial art. The
techniques of photo-graphics, especially,
open up completely new vistas, because
they achieve optical effects never known
before. This book shows how you can
conjure with photographs. It discovers new
fields, offers surprising professional tips
and, last, but not least, suggests ideas for
working creatively and fruitfully with the
knowledge gained. Photographs are an
aid to drawing—photographic techniques
enliven the imagination and are a welcome
addition to commercial art.

# 1   First experiments

*Let us begin, without further ado, with practical trials and experiments. A darkroom is absolutely essential; any attempt to manage without it is doomed to failure from the start. Everything shown here is, after all, not only based on the exposure; it consists of tricks and manipulations that call for a proper workroom. At the end of the book you will find information on how to get by with very simple equipment to begin with. But if you seriously consider the fascinating possibilities of modern photographic techniques, you will realize that your practical scope will rapidly expand. Your own skill, too, will continue to grow, and this book will help you with that too. Study it thoroughly, and you, too, will become a creative photographic artist.*

Since the taking of a photograph requires far less time than the corresponding production of a drawing, the "aid" it constitutes is the role of a time-saving substitute, a kind of "instant drawing", as it were. Where to apply photographic techniques in the practice of commercial art is merely a question of imaginative ideas—and every commercial artist worth his salt is full of them.

Their practical execution need not be discussed. If you can take photographs and make your own enlargements you already have the necessary qualifications. You have merely to combine the use of graphic arts films with the well-known ultra-hard papers. They are extremely contrasty and their designation usually contains the syllable "lith" (Greek : stone), such as Agfalith and Kodalith, whereas Dupont call their process films simply what they are: "Graphic arts films". They must all be processed in ultra-contrasty developer. Apart from the control of exposure most of the work is done on the baseboard of the enlarger where either the graphic arts films or the ultra-hard papers are placed. Images of objects positioned on top of them are either formed directly, or the objects themselves printed in the light cone emerging from the enlarging lens. On paper a white picture on black background (Fig. 1) will be produced;

the same applies to film, but its print on paper will be a black record on a white background (Fig. 2). It is important here to stop the lens down drastically, to ensure a sharp reproduction also of parts of the object projecting towards the lens from the baseboard. In the centre of the light cone the rays are vertically (central projection), and on the periphery obliquely (orthogonal projection) incident upon

1

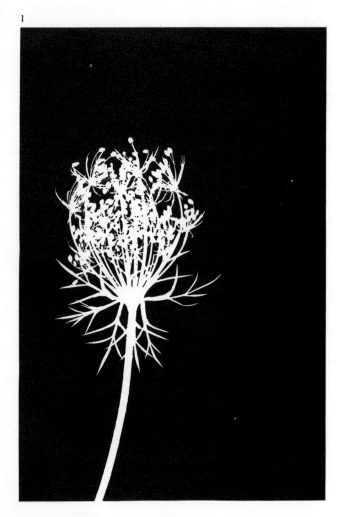

*Simple photogram, made by laying the object on printing paper and giving sufficient exposure to produce a black background to the sihouette.*

the baseboard. Consequently the silhouette images from objects are altered according to their position in the light cone. Fig. 3 shows a watchspring, on the left printed as a uniformly thin line (in central projection), on the right in the form of up- and down-strokes (in orthogonal projection). Fig. 4 clearly illustrates how this comes about. Five cardboard slide frames and three small tubes produce

2

*Paper print from a photogram which was made on contrast film. The black and white areas are reversed.*

The most important thing is an original idea. You can see right away what can be done with seemingly insignificant objects such as a watchspring or small rollers. Fig. 11 is a cross section through a piece of leek; you will see many more puzzling pictures. Any camera can conjure provided it is used by a man with ideas. Fig. 5 is a spiral fire filament drawn out by varying degrees. A print was made from a photogram of this.

3

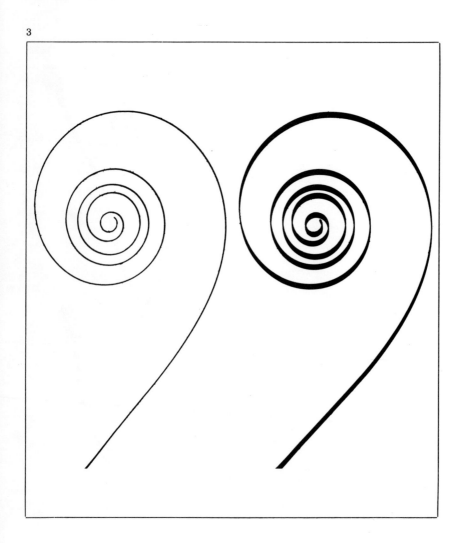

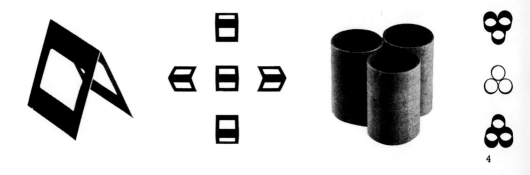

different shadow patterns depending on their location on the baseboard and, consequently, their place in the light cone from the enlarger lens.

The usefulness of this silhouette technique is easily demonstrated. It is far less difficult to stretch spiral wires to the desired extent and print them directly (Fig. 5) than to draw wavy lines.

Circles are produced when foam

from a detergent, squeezed between two sheets of glass, is enlarged in place of a negative (Figs. 6, 7).

Patterns of various kinds will be obtained automatically when two superimposed negatives of a parallel-line drawing (Figs. 8, 9) are enlarged together. As Fig. 10 shows, the most varied changes will occur with concentric circles. Here, two identical negatives of the circles were placed on top of

each other and progressively further displaced relative to each other.

Instead of two negatives, a negative and a transparency made from it can be combined. Fig. 11 shows a cross section through a piece of leek. Fig. 12 is a print of the same negative together with an enlarged, displaced transparency made from it.

Fig. 13 offers an example how to simplify drawing. Camera and lens

*Foam from a detergent was squeezed between two sheets of glass and placed in the enlarger as a substitute negative. Fig. 7 is similar, but at lower magnification— the overall pattern is very attractive.*

6

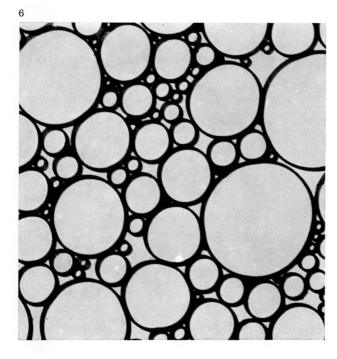

7

*Parallel-line drawings in Figs. 8 and 9 are superimposed giving a fine interference pattern*

8

9

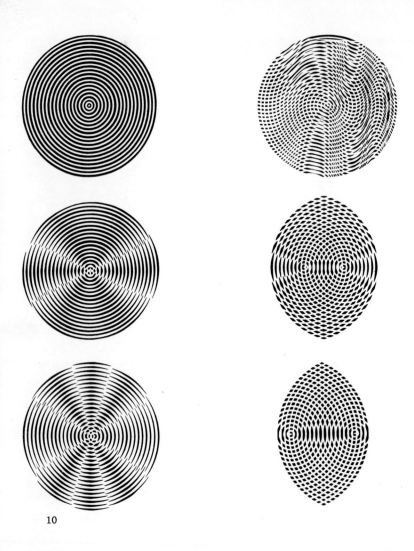

10

Photo-graphic ornaments. Variations are innumer-
able and always very accurate with photography.
All this can be done within an amazingly short
time—just imagine the effort that would go into
drawing them by hand.

14

(top left) were drawn once, re-
produced, and copied four times.
In the other versions (bottom) the
cut-out and pasted-on parts had
merely to be joined, the gaps being
filled in with the pen to demon-
strate the various possibilities of
combination.

*Cross section through a piece of
leek in Fig. 11 was photographed
and a contrast print made from
the negative. Fig. 12, combined
negative and transparency printed
slightly out of register.*

12

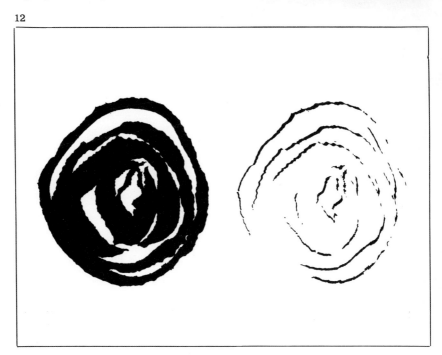

*Graphic conversion of an industrial photograph.*
*A direct print on Agfacontour film produces a very*
*exact and reliable solarization effect.*
*Multiple copies of a line subject save the effort*
*of redrawing, Fig. 13; after cutting out and pasting*
*down the basic parts are joined by simple pen and*
*ink work.*

13

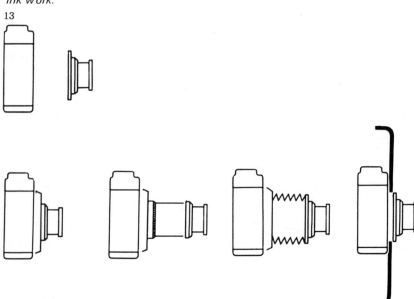

# 2 Conversion
## of half-tone photographs into line

This is a particularly interesting possibility in commercial art. The graphic process can be carried to surprising artistic effects without much effort. But this knowledge serves the commercial artist mainly to obtain black-and-white originals for advertisement illustrations that are suitable for reproduction on newsprint.

The characteristic feature of a photograph is the continuous transition of the grey values from pure white via light grey and dark grey, to deep black. If this is to be preserved in print, only a screen block, whether intaglio, offset, or letterpress, is suitable. The typographer is beset with the greatest difficulties here. A deep black (without screen dots) is still readily obtained during final etching, but a pure white is almost taboo. The screen dots remain. No matter how fine they are, a trace of tone will always appear in the print, the paper does not remain blank, i.e. white.

All the photographs shown here are reproduced from line etchings, except, of course, the comparison pictures, for these are ordinary photographs still showing all the grey tones and therefore requiring a screen for reproduction. To enable the printer to produce photographs in line fashion, they must be converted. The grey tones must be made to disappear so that the dark grey ones become black, the light grey ones white. Failing this a vacuum will occur, a no-man's-land between black and white. If the intermediate, transitional areas are missing, a kind of contour drawing will result. The

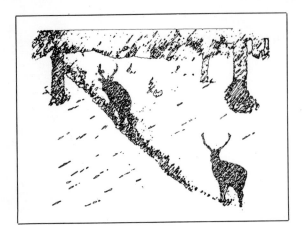

*Stags in a blizzard. Converted into photographic form with Agfacontour film.*

1

*Line print, Fig. 1, was produced by copying the half tone original Fig. 2 on contrast film, copying this again on contrast film to give a negative and printing the negative on hard paper.*

kind of original, and, accordingly, the method to be chosen are therefore decisive.

The simplest process is "contrast printing". A transparency is made of the negative on graphic arts film (lith film), which is contrasty, and a new negative copied off this. If the result is still not hard enough, the entire transparency/ copy negative procedure must be repeated once again. Conversion into a line original is perfect when, viewed by transmitted light, the new negative shows only glass-clear and completely blocked up areas.

This very simple method is suitable whenever the dark grey tones predominate in the original negative, as, for instance, in the picture examples Figs. 1 and 2 (Fig. 2 shows the original photograph as half-tone, whereas Fig. 1, after being copied twice, is printed in line fashion).

3

An ultra-hard print
produces black-and-
white effects resemb-
ling a woodcut.

4

The interesting background
consists of gauze. If you had
to draw this by hand . . .

Example Fig. 3 by its very nature shows hardly any important light tones. Nowhere does it contain any large, grey, uniform areas. As a result, it was possible to obtain a line original resembling a lino-cut after only the first copying run.

Fig. 4 shows the possibility of imitating the character of half-tones also, in line fashion. Gauze material arranged in folds, directly printed on film under the enlarger (as already described), can naturally show only lines corresponding to the individual threads. Where the material was folded, these lines are closer together. The intermediate spaces therefore appear whiter to the eye. Besides the white area (reserved for the text to be inserted) the picture has two grey tones, which can nevertheless be printed in line fashion. Conditions are, however, different when areas of light grey tone predominate in the original negative. These would fall into the "no-man's-land" already mentioned, and be surrounded by isolated portions looking like lonely islands. In that case it is better to dissolve all residues of the picture into outlines after the contrast-copying stage; so that the black islands are now white, and only their contours remain.

For this "automatic" production the somewhat more complicated technique of "solarization" or strictly "pseudo-solarization" is suitable. This is difficult only until you have acquired the knack of it; it is a matter of trial and error, and much depends on the nature of your darkroom equipment.

The principle, in outline, is as follows: After printing, normally the exposed portions are blackened in the developer, and the unexposed portions remain white. If, however, during development, a white light is briefly switched on, the hitherto unexposed portions, too, are exposed and become black.

This is rather as if the already blackened portions of the picture form part of a negative that is now being printed on a film. But since it is the same film, the emulsion becomes black in all those areas that were hitherto unexposed. For reasons that cannot be explained in detail here, thin outlines or "contours" between the first and the second blackened areas remain. The sequence of pictures on this and the next page illustrates the various steps of this process. In practice, as soon as the correct exposure and developing times of a standard transparency have been found on a trial strip, all you have to do is switch on the white light briefly after the first half of the developing time has elapsed. But you should not disturb the developing dish after exposure. The hitherto visible picture disappears, and the emulsion turns completely black within one to two minutes. The previously existing shapes can be seen again only after fixing, and when the film is held up against the light. They have now taken the form of delicate, transparent lines.

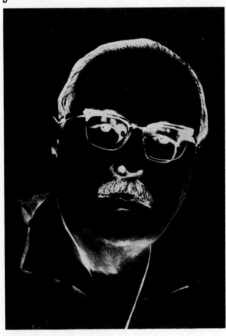 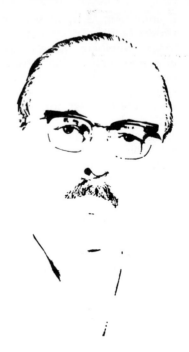

*The various phases of pseudo-solarization
(the portrait photograph used here introduces
the author of this book).*

The film can now be printed or enlarged directly onto paper; and the resulting picture consists of black lines on a white background. As shown in Figs. 6 and 7, white lines on black background are sometimes more effective. This merely requires a transparency from the solarized film, from which the final enlargement or print is made.

The solarized film offers a chance to eliminate unimportant detail or disturbing lines. They are simply painted out with blocking-out fluid.

The solarizing process is particularly simple and reliable with the

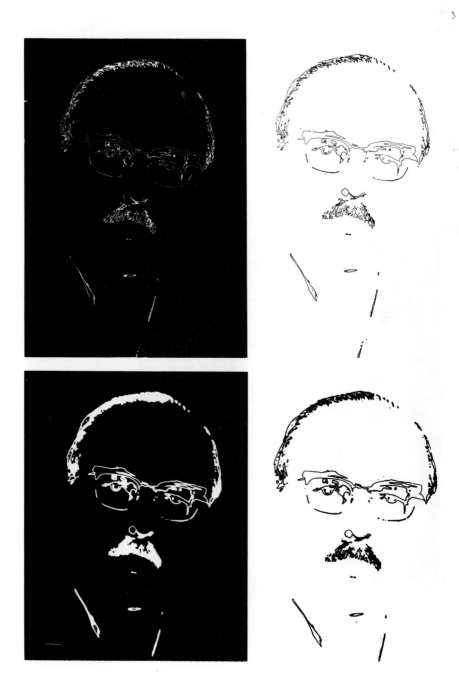

new Agfacontour film. It consists of a single operation without intermediate exposure and precludes failures.

The comparison pictures, Figs. 8 and 9, show further possibilities of solarization. Here the patterns (fishes, in wave pattern, and perforated cardboard) were cut out and, together with a fish hook, placed on a sheet of film, exposed in the enlarger and directly solarized during development. Now only the disturbing lines created by

6

*Original, Fig. 6, was solarized and a transparency made of which Fig. 7 is a print.*

On p. 20 top we saw a picture resembling a woodcut. The solarization on this page can be compared with a mezzotint engraving. Reversing the tones in this way often gives a more attractive result than the original form.

7

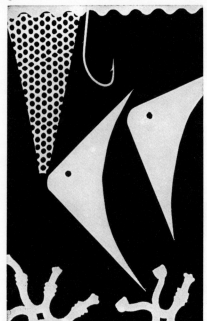

*A fine line drawing, Fig. 9, made by solarizing a simple original design, Fig. 8, which was built up in the manner of a photogram by cutting out shapes and placing them on a sheet of film to make the initial exposure.*

the cutting of the perforated carton had to be blocked out for the film to be ready for printing. If lines are too thin, they can be strengthened ; this, too, is done by intermediate copying ; a matt drawing foil is interposed between negative and film. Before the light rays reach the light-sensitive emulsion they are scattered within the matt foil. They diffuse, i.e. they become broader. At the same time, however, they also become softer and slightly blurred, but this effect

disappears during blockmaking. For Fig. 11, the negative of photograph Fig. 10 was first hardened as in examples Figs. 1 and 2, through copying, and a line screen used in the process. The latter was the reproduction (on film) of wrapping paper whose pattern consisted of innumerable lines in various positions; these can of course equally well be drawn in a similar fashion as an original for a photograph.

*Original, Fig. 10, was copied on contrast film and then printed in combination with a line texture negative which originated from a close up picture of wrapping paper. The result is Fig. 11.*

10

11

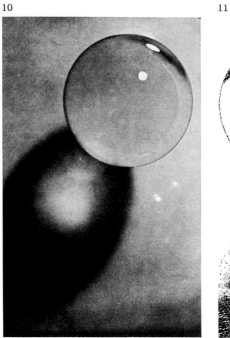

# 3 Conversions for newsprint

## Suitable originals for news-paper advertisements

In reproduction, photographs look different from the original from which the block was made. They appear more grey, weak and flat, in other words they lack "guts". The saturated blacks are broken up by the dot or cross-line screen. The poorer the quality of the paper, the weaker the result. There is an enormous difference between the smooth, even surface of an art paper and the rough, absorbent papers such as the weakly-sized newsprint.

On the former, printing is possible with a fine screen. But coarse-screen pictures are essential to reproduction methods on poor-quality paper. The result is not pleasing. However, photo-graphics deliberately aimed at a final effect are a considerable improvement. You no longer depend on screen reproduction for the printability of your layout. The original is made under your own control, ready for etching; it has the additional advantage of already appearing like the mass-produced final result. Disappointments when you compare the reproduction with the original are therefore avoided.

The aim is always to obtain smooth, saturated blacks as well as pure whites, unspoiled by any screen dots no matter how fine. The various ways of producing this result are shown in examples here.

1

2

3

4

5

6

7

On the previous page and these
two pages the intermediate stages
for the conversion of the photo-
graph Fig. 7 into the line block
Fig. 8 are shown:
1. Negative (copy of Fig. 7), short
exposure
2. Negative, as 1, long exposure
3 and 4. Film positives of 1 and 2
5. Negative of 3 printed through a
wave screen
6. Film positive of 5
8. Enlargement from a negative
obtained by printing 4 and 6
together.

8

9

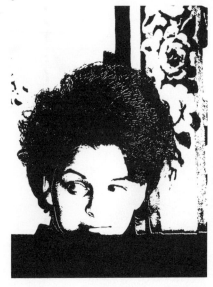

10

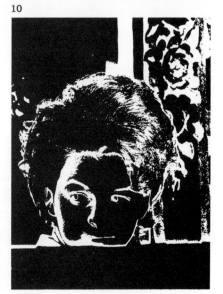

11

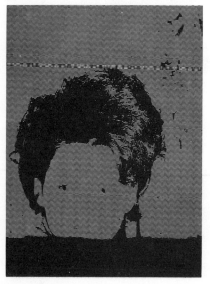

12

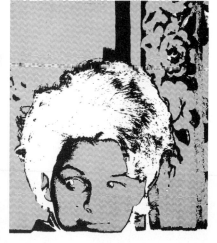

The intermediate stages on these two pages produce a result with greater impact. Positive and negative parts of the pictures are combined here:
9. Film positive of 3 printed together with 4, with slight mutual displacement (*see the white contour*)
10. Negative of 9
11. Film positive of 4 printed through wave screen
12. Negative of superimposed films 9 and 11
13. Final positive print of 12.

13

The simplest method consists of taking the photograph on the smallest possible format on ultra-fast film, developing it, contrary to normal practice, in high-contrast developer, and then enlarging it on a hard paper. Thus the negative grain becomes visible, and replaces the screen dots which would have to be specially pro-

*High magnification of a coarse grained original processed in contrast developer gives the "rough" quality desirable for reproducing half tones on newsprint.*

14

duced by process engraving at a later stage. Examples, Figs. 14 and 15, show that this method is suitable above all for simple, contrasty, and naturally 'rough' patterns.

Smooth half-tones must be broken up to give them a visual grey tone effect. In Fig. 16 the negative was simply printed through a piece of cloth. Naturally, the eyes and

*Even greater enlargement may, in effect, turn the illusion of half tone areas into a boldly fractured line image.*

15

**16**

*Tulle produces a delicate screen effect, obliterating the typically photographic impression.*

*The result resembles a drawing.*

**17**

**18**

mouth of the Trojan terracotta mask lost some of their tone range because there, too, the structure of the fabric was reproduced. But the shapes are so simple that it was possible to isolate them without difficulty by means of a black felt-tipped pen.

For more complicated patterns two copies on hard film must be made of the photograph or the negative, one at a relatively too short, the other at an excessively long exposure time. The result is two negatives of different densities, one showing the rough contours and little or no detail, the other, the structure and detail within the more or less neglected outlines, as illustrated by examples Figs. 17, 18, 19. Fig. 18 is derived from the excessively exposed negative, which would have the effect of a silhouette if it had not been broken up during copying by printing through a superimposed fabric screen. It therefore looks grey instead of black. Fig. 17 is a hard copy of the negative that had too short an exposure. It shows only the differentiation within the broken up outline. In the final result (Fig. 19) the two films Figs. 17 and 18 were copied together, producing a line original consisting of black, grey, and white. Other effects can be obtained with line screens available from commercial artists' suppliers.

A hard (contrasty) film transparency can be copied twice through such a line screen so that, as in Fig. 20, the lines run from top left to bottom right in the one, and from top right to bottom left in the other print. (All you have to do to obtain this effect is use the screen first through the front and then through the back.) In addition to the whites, which remain completely blank, the copying together of the

19

two superimposed films produces two grey tones which, owing to their different structures, can have a most attractive effect. The light grey is produced by the line structure of the screen included in the print, and the dark grey by the intersection of the lines in the transparent areas. On close inspection it will be found that the picture consists both of parallel and of crossed lines; the latter do not produce, a pure, i.e. uniform, black. Continuous black areas will be obtained when the lines run in only one direction but two negatives are printed together as, for example, shown in Fig. 21. All you must do is displace the two negatives exactly by one line width when you superimpose them so that the black lines of one negative block the clear ones of the other. Correct matching thus yields clear whites as well as uniform blacks in addition to the grey simulated by the lines.

The photograph shown in Fig. 22 has also been printed through a line screen, but directly, and only from a single negative. This, however, requires "unsharp" screen lines. To obtain these a sharp line screen is printed through a matt drawing foil; this transforms the sharp lines into unsharp ones. If a hard negative is now printed through such a softened line, the lines will become broader where only little light reaches them, and narrower where much light passes through them. This illustration (of a varnish mill) shows that the

lines are completely obliterated in
the blacks, and that they become
narrower along the transitions to
grey and white.

*Photograph of a varnish mill converted into a contrast negative and
printed through a soft line screen on to hard material. Note the "gradation"
obtained by this method.*

22

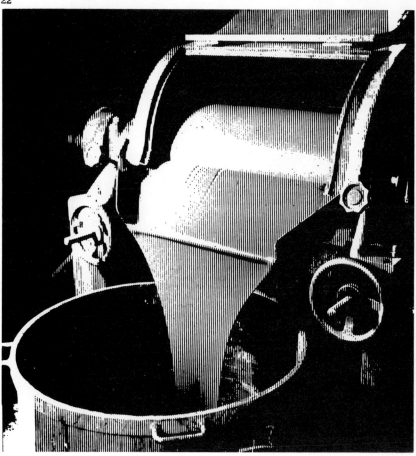

# 4  Duplications

Classic example of multi image photography: a silk bow
photographed though an improvised kaleidoscope made up
from three mirrors.

1

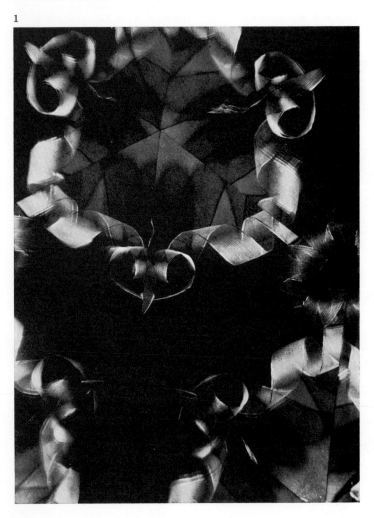

Time is money. The less time you need to spend on production, the higher your income. It is only natural that you should make use of technical aids that cut down operating time and produce results sometimes even more precise than pure manual work. Here we are

*A multi tone photogram made by laying pieces of paper on the bromide sheet, partially exposing, blowing away some pieces and exposing a second time.*

2

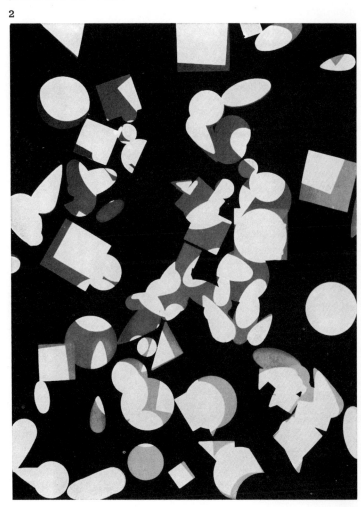

dealing mainly with photography as an aid to duplication. It is not necessary to repeatedly draw subjects which reoccur in the layout plan. It is better to draw them once and then to duplicate them photographically.

Fig. 1 is a classical example of

*A straight photograph of a turkey feather.*

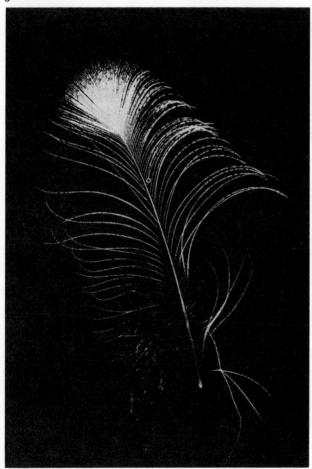

such multiple printing. It is a photograph of a silk bow—photographed through a kaleidoscope, a popular toy which as most people know, when you rotate it while looking through creates innumerable patterns. Such a kaleidoscope is, however, too small for photo-

*The feather photograph combined with a negative copied from it, solarized, and slightly displaced.*

4

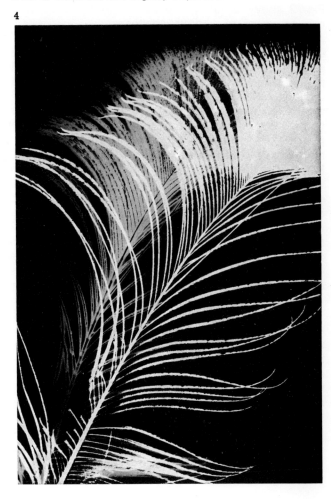

graphy, mainly because the camera lens is larger than the viewing pupil of the kaleidoscope. Three mirrors (about 12×30cm, 5× 12in) combined to form a triangle along their long sides and mounted in front of the lens allow you to photograph the regular ornamental patterns created by the mirrors as the eye sees them.

Fig. 2 shows a random pattern: bits of paper of various shapes (confetti) were distributed on a sheet of bromide paper under the enlarger and a brief exposure made using light from the enlarging lens. After that, gently blowing across the paper covered by the confetti was enough to change the pattern. The enlarger light was now again briefly switched on. Finally the paper was developed. Where the bromide paper remained covered by confetti during both exposures it remained white; where it was covered only during the first exposure, it became grey during the second; and where it remained uncovered during both exposures, a jet-black background was produced.

The pictures on the following pages show the difference between the photograph of a turkey feather (Fig. 3) and the combination of this photograph with a negative copied from it, solarized, and slightly displaced. The empty space in Fig. 3 has been filled by the duplication in Fig. 4.

The main aim of Figs. 5 and 6 was to render the concrete aspect of objects, as abstract shapes. The tools were placed individually on sheets of film and printed as silhouettes in the enlarger. Both thin and dense transparencies were made of these films, superimposed, and mounted with adhesive strips on a glass sheet in a suitable position. Fig. 5 shows the superimposed positive films with their different transparencies, and Fig. 6 the final copy of this combination.

## Playing about with geometry

The next illustrations show what can be done with drawings of two rectangles in the simplest possible way with the aid of photographics. The arrangements Figs. 7–10 begin with the first rectangle, which (on the right) is printed together with the second rectangle (not shown here). The drawings Figs. 9 and 10 consist of the repeatedly overprinted films Figs. 7 and 8.

Figs. 11 and 12 are designed to show that blurred, flowing lines representing luminous patterns or fluorescent tubes can be produced much more simply by means of photography than with pencil, pen, brush, or spray gun. To create the effect of Fig. 12, the film of Fig. 11 was merely enlarged out of focus. A little more time-consuming than the methods described so far is multiple printing. It is of interest when the pictorial elements are of different sizes and have to be reduced or enlarged to certain dimensions. Figs. 13–15 show how it is done. Four separate negatives (a air brush, three

brushes, two pencils, and a rè-touching knife) are successively enlarged on the same sheet of bromide paper at different exposure times.

Development can take place only after the fourth exposure. To save yourself disappointment you must have continuous control of the spatial arrangement. For this pur-

*Tools printed individually as silhouettes from which transparencies were made at different densities and superimposed, Fig. 5. Below, Fig. 6, is a combination of the copy.*

5

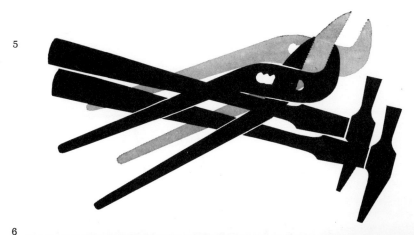

6

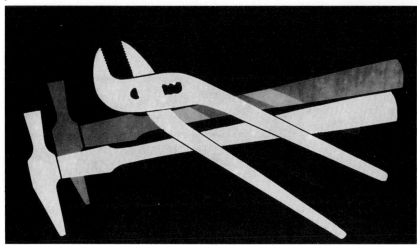

The two rectangles at the top, repeatedly
printed on top of each other, produce the
photo-drawings at the bottom.

7—10

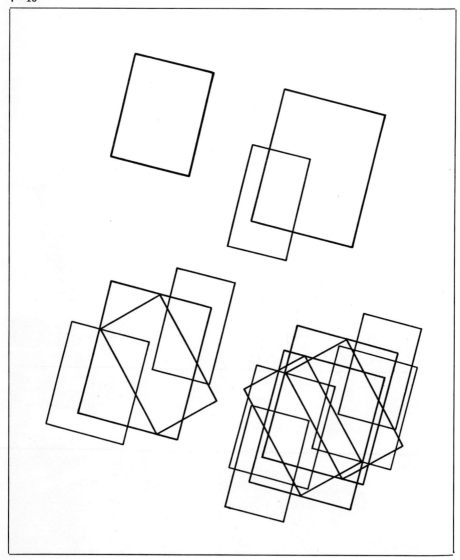

pose insert a sheet of cardboard of the same size as the bromide paper in the masking frame after each exposure, and trace the contours of the negative focused on it. When the second negative is inserted in the enlarger the new image can be matched in space to the previous one and harmonized with it. This tracing must be carried out before each change of negative. The desired density, too, must be determined each time with a trial strip. Finally, it is very important to

*A soft line can be produced more efficiently by photography than with a brush or airbrush spray simply by printing a hard line a little out of focus, Fig. 12.*

11

12

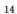

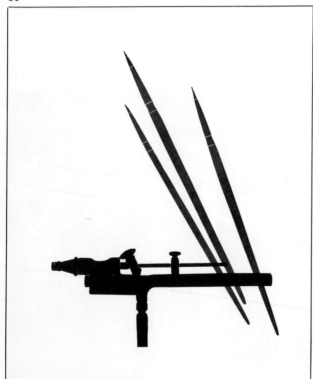

*First, Fig. 13, and second, Fig. 14, stages in producing a design by combining related photographic images.*

mark the back of the bromide paper to identify top and bottom. Once the paper has been inserted up-side-down by mistake the whole effort—as you will be able to see only afterwards—will have been in vain, and you have to start all over again.

*These silhouettes were produced by direct printing. An interesting effect can be achieved even with the simplest objects. But don't be content with only one arrangement. Just as the artist draws several sketches, you can produce several photo-graphic ones. Continual experimentation is one of the secrets of success for a photographic artist.*

15

# 5 Graphic montage

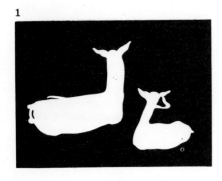

1

2

3

Reproductions of drawings offer wide scope for variations. Films—superimposed or multiple printed—convey a clearer impression of the final effect than carbon tracings which have only the character of drawings. What is merely a vague, not yet final idea can be developed more quickly to the intended form, or even lead to a composition totally different from that of the original plan. Good examples are Figs. 1–3. Fig. 1 shows the negative of a photograph of a prehistoric cave painting. In Fig. 2 it is reproduced as a positive, printed together with a line screen, the lines running from top to bottom, both in the doe and in the kid. As soon as the direction of the lines is changed, i.e. running vertically in one, horizontally in the other subject, a new possibility is created as illustrated in Fig. 3. It was possible to convert a horizontal into an upright picture without loss of clarity. A new grey tone in the kid's neck and head was produced by the superimposition of the two line directions. We thus have not only a modification, but a newly constructed picture, which could be produced with hardly less effort. Such a construction can also be brought about systematic-

*The subjects in Fig. 1, originated from cave paintings. In Fig. 2 they are printed in positive, combined with a line screen running vertically. With the subjects rearranged, and superimposed vertical and horizontal screens, Fig. 3, a new tone is produced. Photograms of the tulip petal and stamen are combined in printing.*

ally. Figs. 4 to 6 show the creation of a stylized tulip. The direct copying already mentioned in the previous chapters produced to begin with the silhouette of a real, feathered tulip petal. Later the stamen was printed into the transparency (Fig. 5). During this process the stem, i.e. the support, became submerged in black. The picture was disappointing. Negative Fig. 4 was therefore once again copied through a line screen so that a (simulated) grey tone resulted. The stamen and, in addi-

*The simplest subjects explain the technique most clearly.*

4

5

tion, the pistils were once again printed into this new negative. The stem of the tulip, too, now stood out against the (apparently) grey background. Fig. 6 shows the final picture after the text had been printed in.

Whereas these manipulations required merely a sense of proportion rather than dimensional accuracy, the latter played an important part in Figs. 7–9. The combination of photography and typography here presents the special feature that the black, positive types

6

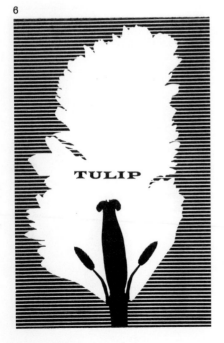

Graphic picture of a tulip produced by multiple printing of various negatives.

*If a picture is to be combined with a typographical motif it is an advantage to start with a photograph which has a strong form and outline such as that above.*

become negative corresponding to the contours of the photograph in such a way that they are a precise continuous match. First a contrast print had to be made of photograph Fig. 7 to obtain a transparency functioning like a mask and to be copied together with the reproduction of the type numerals so that these were completely covered by the hand. Fig. 8 shows the print of this new transparency. To produce a negative precisely matching this montage film registration marks (crosses) were scored in the emulsion in two places (top left and bottom right) with a needle. When copying the

transparency of Fig. 7 together with the transparency of the numerals these marks had to be in register. Arranging the super-imposed negative and positive so that the registration crosses were precisely matched also ensured a continuous matching of the number sequences where they changed from black into white or grey.

In the Figs. 10–13 series of pictures the original photograph of the herring barrels had first to be transformed into a graphic repre-sentation (here consisting of lines). Fig. 11 shows the negative, which is automatically produced with the "tone line process" from

*A contrast transparency of the original in Fig. 7 was printed in combination with a typographical positive to produce Fig. 8 where the subject acts as a mask.*

8

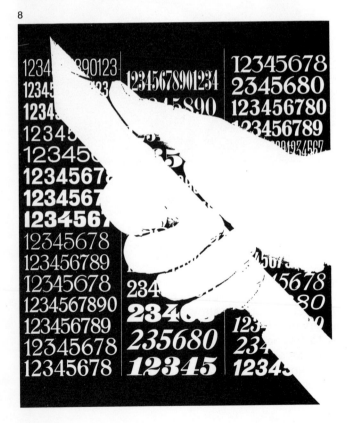

more or less sharply outlined black lines. Fig. 12 (white lines) is a print of it.

This is how it is done: a transparency must first be obtained from the original negative, corresponding to the latter in density. Negative and transparency are now superimposed with a stiff matt transparent sheet sandwiched between them so that only a uniform, opaque area is seen in a perpendicular viewing line. In an oblique, lateral view, however, fine lines will appear which vary in breadth according to the thickness of the interposed sheet; this creates a space between the two

*A negative was made of Fig. 8 and then combined with it to give the part-positive part-negative effect seen in Fig. 9.*

9

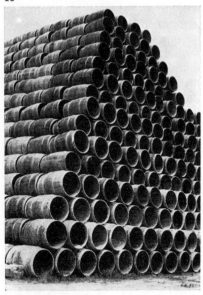

films through which light can penetrate. In this position, back to back, the films are mounted with adhesive tape on the glass sheet of a printing frame. After inserting a sheet of graphic arts film or bromide paper the printing frame is closed and placed on the turntable of a record player. The object of this is to rotate it evenly so that the beam from a 35mm projector set up obliquely to the right or left can pass through the narrow space between the two images from all directions. The areas of the photograph Fig. 10 are thus broken up into lines (Fig. 11). The final picture (Fig. 13) is printed from the negative Fig. 11 together with a film on which the

*The original subject in Fig. 10 was converted into a graphic image by using the tone line process. Fig. 11. Fig. 12 was a print made from this. Fig. 13 shows the herring barrels combined with a multi-printed photographic copy of a hand-drawn herring.*

11

12

*Combination of photograms printed from three separate films.*

same drawing of a herring had been photographed three times. Fig. 14 BP, the British Petroleum company had a plastic puzzle game made of their firm's emblem "BP". The idea was to detach the P (consisting of a loop with a movable arrow) from the B, with which it was linked. The picture was printed from three films.

## 6 Optical effects

It is in the nature of photography, which produces pictures by optical means, to also offer scope for recording optical effects extending beyond image formation proper. Photography is inseparable from optics; optical effects can there-

*Semi-abstract composition from the reflection of window bars in a piece of mirror glass with the focus on the mirror surface rather than the reflection.*

1

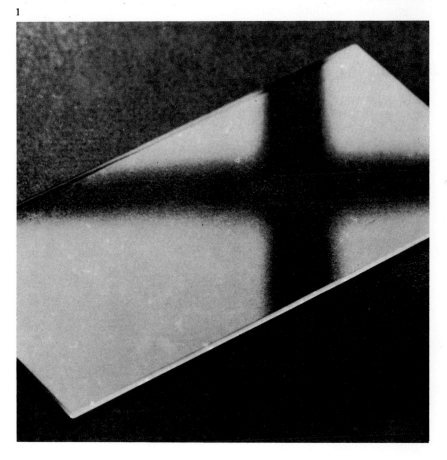

fore be represented more efficiently and effectively by photography than with brush or pen.

In the field of painting, the Old Masters knew what they were doing. They did not just place the highlights in the eyes as white dots but painted them in such minute detail that even the bars of a window were reflected there. Without such detail the sparkle of these highlights would not have been natural.

In photography, highlights are generally undesirable technical adjuncts. But when sparkle is to be reproduced, here, too, the window bars included in the picture are helpful. The picture of a mirror glass plate (Fig. 1) shows what we mean. In addition to the reflection, the magnifying effect of the lens can be particularly well rendered by photography. Drops of water on fabric (Fig. 2) not only demonstrate that the material repels water, but also show the typical magnification of the fabric stitch seen through the water, which acts like a magnifying glass. The physiognomic changes (using bifocal spectacles) are based on the effect of the different dioptre components of the spectacle lenses being made visible. It was produced by laying the spectacles on a sheet of bromide paper, and exposing with a pocket torch in various positions and from several directions. Indifference, interest, friendliness and an easygoing disposition (Figs. 3, 4, 5, 6) can thus be rendered in abstract repre-

sentation. Ordinary photographs, too, can be optically changed at any time. Fig. 10 is an example with only very little to remind you of a photograph. The dissolution of the contours, which look as if they had been applied with a brush, was produced through the enlargement of the negative together with a sheet of moulded glass such as that frequently found in glass doors. It has a "hammer finish" surface. The ir-

*Droplets on waterproof linen demonstrate how water can act as a magnifying glass. Figs. 3–6 show how spectacles can assume facial expressions when placed in different positions.*

2

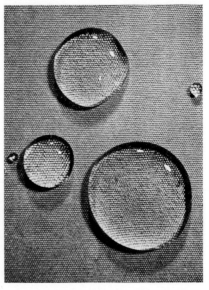

3

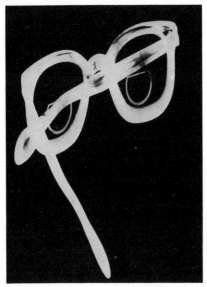

4

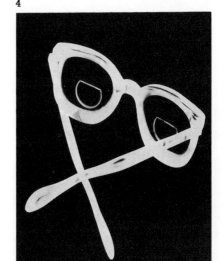

5

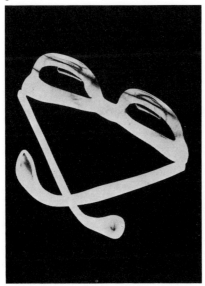

6

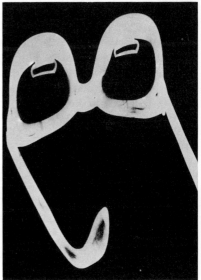

*Enlargements through moulded glass placed under the negative. Fig. 9 was combined also with an out of focus negative of wrapping paper seen in Fig. 8.*

regular texture breaks up the areas of the negative during enlargement according to its own structure— but only if there is sufficient separation (about 10 to 15mm) between them. The sequence must be as follows: light source, condenser, negative, empty space, moulded glass, enlarging lens, bromide paper. The lens must be focused on a middle distance between negative and glass; sharpness is obtained by stopping down. Fig. 7 shows the structure of such a piece of glass with the lens focused on its surface. In this case the negative areas are not broken up.

Fig. 9 shows a montage of a portrait with the out-of-focus re-

9

10

**11**

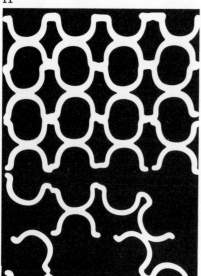

**12**

*A direct photogram of drawer handles. Fig. 11, combined with the grooved glass seen in Fig. 12 produced the effect in Fig. 13.*

production of a piece of wrapping paper for oranges (Fig. 8). The trade mark "Baci" in the centre was first removed by reduction. Both negatives were then super-imposed and enlarged through a moulded glass plate.

Grooved glass (Fig. 12) produces different effects in these condi-tions. The direct print of 33 joined drawer handles (Fig. 11) when enlarged through grooved glass resulted in the picture Fig. 13. The letter H (a pattern cut from a piece of cardboard) was lying on the bromide paper during the expo-sure.

Whereas in the cases described so far, only the optical effect caused by the structure of the glass but not the irregular surface itself becomes visible, in Fig. 14 the

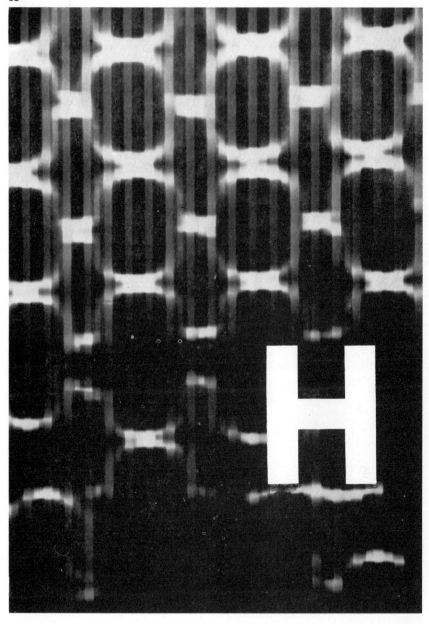

latter can also be seen. The surface of the glass is composed of innumerable little "bumps", which act like so many lenses (lenticular glass). Their highlights can be seen particularly clearly along the picture margins. The picture shown consists of an ordinary photograph, reproduced through a sheet of lenticular glass supported by two about 10mm thick spacing strips.

Figs. 15 and 16 demonstrate the light-collecting and diverging effects of glass lenses. The shape and transparency of the glass components are as clearly revealed as the transmitted light ray modified by it. The photographs were taken in a darkened room in the cone of a narrowly stopped-down spotlight; the background was a piece of black, slightly rough cardboard. The beam was directed so that the light bundles produced by the lenses were incident on the cardboard background. The fine fibres of the rough cardboard

14

*Ornamental glass has alienated the photograph and produced a pointillistic effect.*

**15**

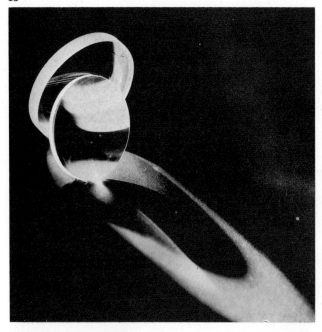

**16**

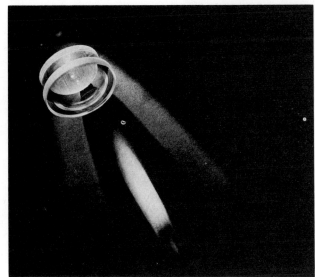

*Here it is not the shape of
the lenses that counts,
but the optical effect of
the curvatures.*

surface reflected the light, making it visible. Glass bodies of various kinds inserted in an enlarger instead of a negative create peculiar shapes. Fig. 17 shows glass beads enlarged in this way. A little bowl was filled with them so that some were isolated (the grey shapes) and others superimposed (the white, intersecting shapes). The lid of a little Perspex box served as a bowl; its rim was so low that it

*Glass beads were placed in the carrier of the enlarger and enlarged as if they were a negative, to produce Fig. 17.*

17

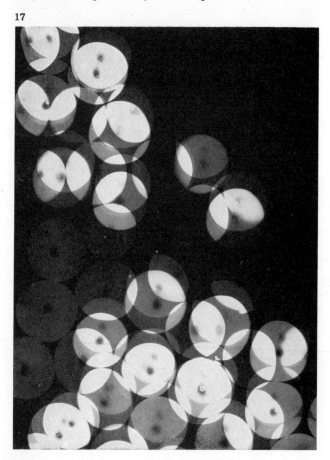

fitted in the slot of the negative stage of the enlarger.

Fig. 18 is a composition consisting of negative "silhouettes" of spectacle and other lenses of various sizes. They were placed on a glass plate in the negative stage and directly enlarged onto paper like a negative. To increase the contrast the enlarger lamp was slightly decentred so that its light reached the lenses from one side.

*Various lenses were placed in the carrier and enlarged with the lamp off-centre.*

18

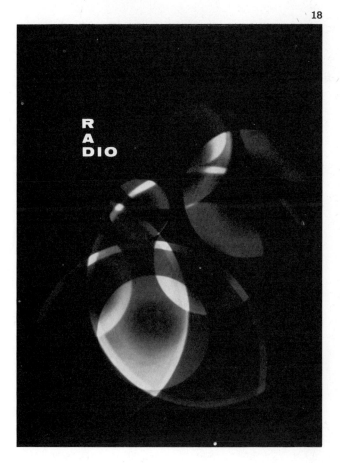

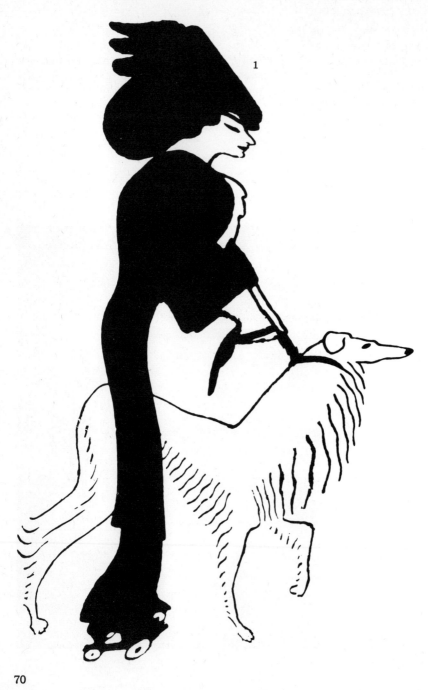

*Copies of a drawing, Fig. 1, made by photographing through a distorting glass brick placed at various angles.*

# 7  Distortions

Nature, and its likeness, if this likeness if produced by photography, differ only little. Except in the colour photograph the natural colours are reduced as different values of grey. There are further differences: that between the dimensions of the original and of the reproduction, and the reduction of three-dimensional reality to two

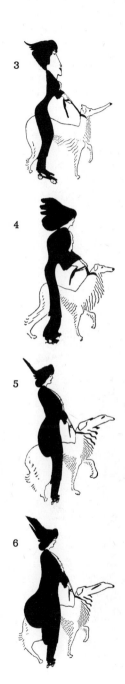

dimensions. Apart from these points, however, all the details of the photograph completely agree with reality. This feature of perfect representation is an odium which photography has to live with, and accounts for the efforts to achieve an individual control of the result. Here the photographer is far more restricted than the painter, the draughtsman and the cartoonist.

*Distortions in Figs. 7 and 8 were created by photographing reflections in a silver globe.*

7

All these start with an empty area, within which they build up their picture, stroke by stroke, whereas the photographer must reduce the abundance of detail that naturally obtrudes on him. This explains why many tricks that have been used for decades, are on the one hand done with tawdry results, but on the other show an expression of personal creative effort through the omission or addition of pictorial elements (fading out and fading in).

Here we are concerned mainly with conversions or distortions of forms without omitting anything or, as in montage, adding something unrelated.

Photographs taken in distorting mirrors on fairgounds have been familiar for years. After you have managed to pass through the maze of mirrors set up at angles, you are suddenly faced with two curved mirrors, in one of which you can see yourself excessively slim and elongated, and in the other compressed into the shape of a fat toad. You can also take photographs of your distorted self. Such curved distorting mirrors are, of course, also suitable for other photographic purposes, but they are difficult to obtain. Polished chromium-plated glazing sheets for print drying can, however, take their place. For photographing distorted mirror images they merely have to be bent lengthwise or transversely.

Simultáneous distortions of the vertical and horizontal can be

successfully obtained in a silvered, globular Christmas tree decoration. Figs. 7 and 8 show faces which are excessively distorted, because instead of the faces, their reflections in a silver globe were photographed. Similar distortions are possible with fisheye lenses. Distortions can be produced from an existing normal photograph at a later stage, i.e. during enlarging, if the bromide paper instead of lying flat is set up obliquely or bent in one direction or the other. Figs. 9–12 illustrate this method and require no further explanation. The shapes of the original photograph Fig. 9 are elongated because the paper was bent transversely whereas when it was bent lengthwise, they were spread sideways. Irrespective of the method, the tricks described so far result in stretching, elongation and arching, corresponding to the narrowing and broadening caused by the distorting mirrors. But in the example shown here the basic shape, the contour, cannot be fundamentally changed as in the examples shown in Figs. 1, 3–6, and 13–15. This method is founded on a variant of the method of copying transparencies by transmitted light. The important difference consists in inserting a glass brick between original and taking lens. Such a hollow glass brick normally measures $18 \times 18 \times 8$cm. Its surface is irregularly wavy. The effect of this is that light can pass through, although one cannot see through. Glass bricks are fre-

*The pictures on the facing page are limited to only a few basic shapes, which can be produced by photographic distortion in enlarging (most clearly shown by the silhouette of the head).*

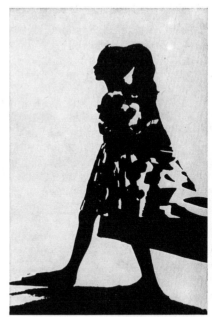

quently used in the staircases in modern buildings, where they form a uniform external wall replacing a window front.

When you have found such a wall, you need only a single brick, at chest level and accessible from both sides; from outside so that the original can be mounted there, and from inside so that the photograph can be conveniently taken through it. Behind this brick there should preferably be empty sky, i.e. it should be unobstructed by buildings, trees, masts, or similar features. The picture to serve as original should be a transparency not larger than $9 \times 12$cm, so that it can be moved in both directions within the $18 \times 18$cm glass area. The transparency is backed with a matt tracing sheet or a piece of imitation parchment paper, and attached to the outer face of the glass brick with two adhesive tapes. It can now be shot from

*Facial distortions obtained by shooting through a glass brick which may already be installed in the wall of a building.*

13

14

inside. The waviness of the two surfaces and the uneven thickness of the brick alter the contours whenever a new camera direction is chosen. The lines that cave in or bulge continuously vary depending whether the camera position is slightly to the left or to the right, or to the top or to the bottom. Further variants can be produced when the position of the transparency within the 18×18cm sur- face of the glass brick is changed (hence the advice to use the 9×12cm film format). Further- more, the transparency can be mounted on the glass surface upside-down or rotated through 90°; this results in new distor- tions. Because of the optical effect of the varying thickness of the glass, with surfaces about 8cm apart, a sharp picture cannot be obtained at full aperture. The sub-

*An optical illusion, whereby the girl's face appears much wider, is set up when enlarging her picture combined with a negative of concentric circles.*

16

17

*A bit of sorcery. The Supercortemaggiore dog,
familiar to motorists touring in Italy, can be
"mutated" at will. This is great fun with black-and-
white originals without half-tones. Skilful cutting
and pasting plays an important part.*

ject must therefore be focused at a large stop and exposed at minimum aperture (f22 or f32), for, in contrast with ordinary copying there is a problem of gaining sufficient depth of field within the 8cm separation between the two glass surfaces. Finally, two further tips: a calm day with overcast sky offers the best conditions. The transparency film will then not flap during the exposure, and the overcast sky, will provide diffuse or scattered light and that cannot produce highlights on the glass surfaces.

Figs. 1 and 3–6 show variants produced in this way with a fashion cartoon dating back to 1905 (original above the chapter heading) "How to walk in spite of narrow skirts".

The variations on the "Cortemaggiore" dog (Fig. 17), the emblem well-known to motorists touring Italy, were produced by inserting or cutting a section out of the middle part of the body, and adding some more flaming tongues; thus the dog loses or gains pairs of legs, compensating for the loss with an increased fiery breath. No difficulties arise, since the original is silhouette-like without grey tones. The strange effect of the girl's head (Fig. 16) is based on an optical illusion. The portrait was enlarged together with a film (copy of concentric circles). The circular lines superimpose the slim, oval shape of the face, making it appear wider—in this case more youthful and girlish.

*Variant of a distortion through printing with as high contrast as possible. Portrait of an English judge with wig? No, just a photograph of a simple walnut kernel.*

# 8 Bringing movement to rigid shapes

The photographer has the choice of three methods for recording movement in a still picture or to simulate dynamic action—moving the camera, blurring the subject, and following the movement of the subject with the camera. All three methods demand an exposure time that is too long for the speed of the movement. Here is an example, without any detailed explanation of the distinctive features. If a car passes you at 140 kmph (90 mph), and you take it at 1/30sec shutter speed, you will obtain a ghostlike "wipe" picture

*Suitably bent wire Fig. 1a, when lit and rotated against a black background gives the aerial image seen in Figs 1b and 1c.*

1a

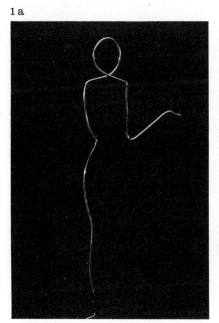

1b

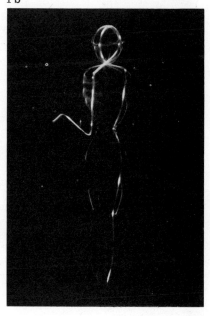

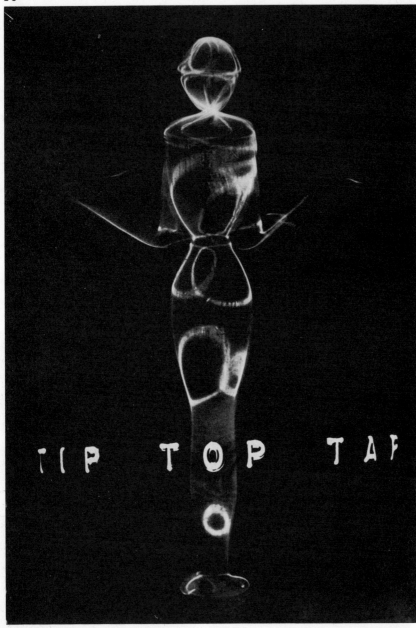

instead of sharp contours, and you can guess the speed of the car from it. At a shutter speed of 1/500sec, presumably a sharp, but "frozen" reproduction of the car would be the outcome, and there would be nothing to indicate its speed.

These are the possibilities open to the conventional photographer. The practitioner of photo-graphics has a wider scope; he can transform immobility into movement, areas into space, even "dematerialize" concrete objects. The procedures to achieve these effects

*An abstract shape made from bent wire, when revolved, gives the roughly symmetrical shape seen in 2b and, by combination, the effect in Fig. 2c.*

2 a

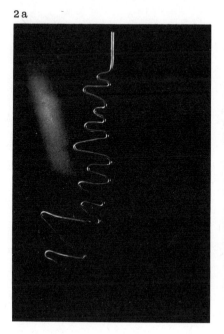

2 b

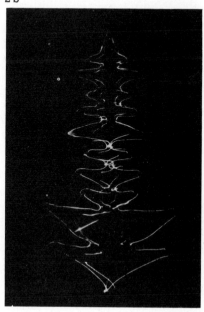

are either founded on carefully planned photographs or make use of tricks during enlarging. The pictures on pp. 81 and 82 show how suitably bent wires (Figs. 1a and 2a) produce "aerial figures" if they are rotated in front of a black background during a long exposure. All you have to do is mount them axially on the turntable of a record-player or on a tape recorder with modelling clay or some other suitable adhesive and switch the instrument on. Fig. 1b shows a three-quarter turn; Figs. 1c and 2b were produced during a rotary movement of longer duration. The wires can no longer be recognized as such. Only their highlights, sparkling in the light, produce the unreal "aerial figures" during rotation. The montage (Fig. 2c) shows the negative enlarged through a granular screen together with a transparency made from it. The screen is intended to convey the impression of a blizzard.

The enlarging process adds three further possibilities of introducing movement into an already existing negative. The masking frame can be displaced in one or the other direction or rotated. Both can be done either continuously or in steps, as required.

In addition to horizontal displacement there is the possibility of vertical sharpness adjustment: the enlarger head is raised during the exposure, or the sharp setting of the enlarging lens changed so that it produces considerable unsharpness.

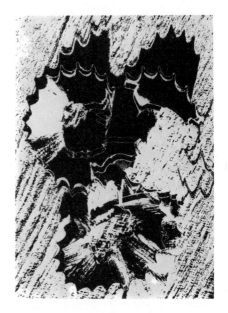

*Variant through displacement of a curled woodshaving produced during pencil sharpening.*

*Montage of a negative and larger positive made from spinning wire figure printed together through a grain screen.*

84

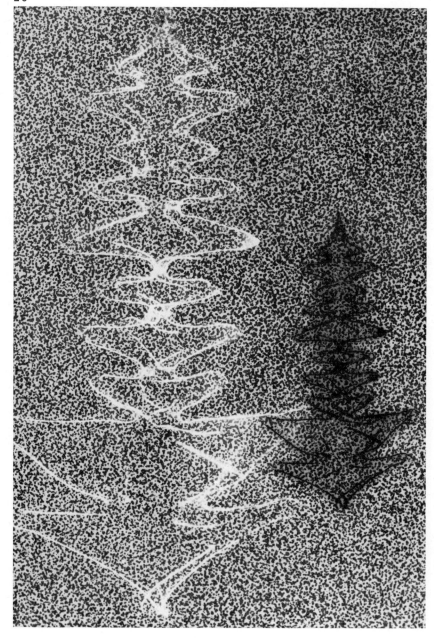

3 a −b    3 c

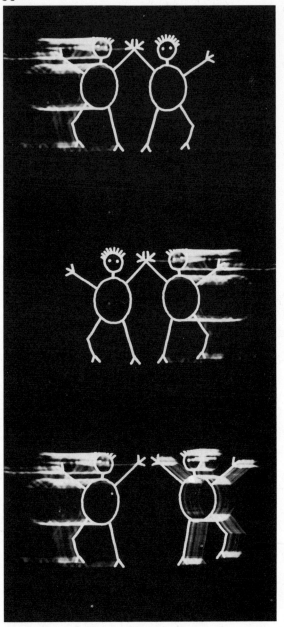

The 35mm negative, Fig. 3b, of a child's drawing, 3a, was enlarged on graphic arts film three times— once in the ordinary way, i.e. rigidly, and twice with a transverse displacement of the masking frame. The films were then superimposed laterally reversed and printed together. The picture series in Fig. 3c shows that the displacement in the "trial of strength"

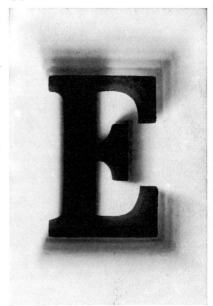

*Fig. 3b and c are variations of Fig. 3a made by moving the film, on which they were enlarged, during the exposure and combining the resulting films in a single print.*

*The effect in Figs. 4b and c result from moving the enlarger head to several positions during the exposure of the negative of Fig. 4a.*

4 a

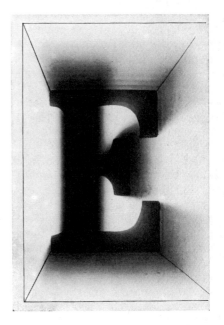

of a minute hand on the face of a clock. The "steps" are large in Figs. 6b and 6d, small in Fig. 6c. The picture sequence 6a–d shows variants that can be obtained during enlarging on a centrally-placed masking frame from a hard negative (glass beads—Fig. 6a) with jerky rotation.

If the masking frame is moved between the two little men was continuous in one case and step by step in the other.

The pictures in Figs. 4a–c are examples of making vertical adjustment to the enlarger during the exposure. In Fig. 4b the instrument, with the copy negative of the letter E (Fig. 4a), was raised higher and higher at short intervals. In Fig. 4c it was raised continuously. This gives the letter E the appearance of a door at the end of a corridor. In both cases the two-dimensionality of the reproduction has been given a third dimension. Special effects are created when the masking frame is rotated round an axis during the exposure. The axis may be central or eccentric; the results differ accordingly.

The examples Figs. 5a–c and 6a–d demonstrate only a fraction of the possibilities available. The masking frame is placed on a turntable rotating like a potter's wheel instead of on the enlarger baseboard. If it is positioned precisely in the centre and rotated jerkily through a few degrees, contiguous repeated reproductions will result, corresponding to the jerky progress

*After three exposures of the same negative, Fig. 5a, on the same paper—rotating the masking frame through a few degrees each time—the eyecatching picture on the facing page was obtained.*

5 a

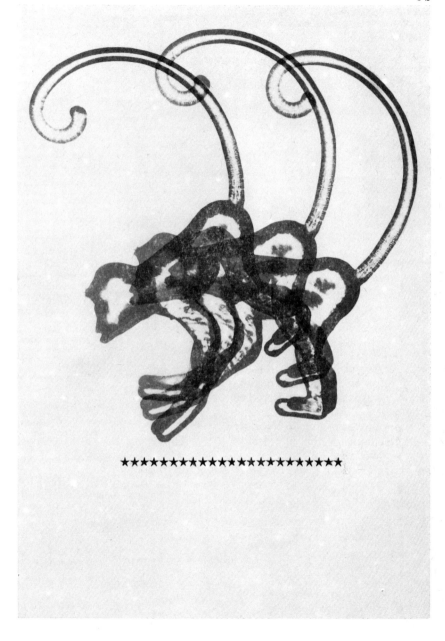

★★★★★★★★★★★★★★★★★★★★★★★★★

*Feeling of movement in the rotating image—an image caused by rotation around a fixed point.*

away from the centre of rotation of the turntable, i.e. placed eccentrically, phases will be produced as shown in Fig. 5b (triple exposure of the monkey) and in Fig. 5c (enhancement of the impression of the leap through continuous movement).

*A simulation of the cinematographic effect is possible by exposing at intervals during the rotation of an image, Fig. 6a and 6b.*

90

6 a

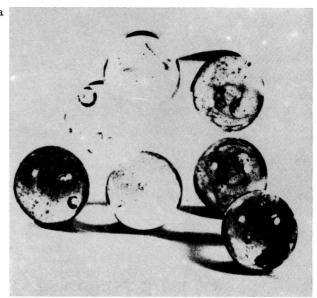

6 b

# HELLAS

*The compelling effects obtained by rotating the print-down material or paper during enlargement lend themselves to combination with typographical layouts Figs. 6c and 6a.*

In these enlargements the total exposure time is the sum of many individual exposures. Both were made from the negative Fig. 6a. The position of the centre of rotation is visible in Figs. 6b and d, and invisible in Fig. 6c because of the local density of the negative.

Irrespective of the subject chosen, the regular structure obtained bears a certain resemblance to seashells and marine snails. This technique was used in Fig. 6c to reproduce the head of a bearded Trojan warrior to make him look like a phantom.

6 d

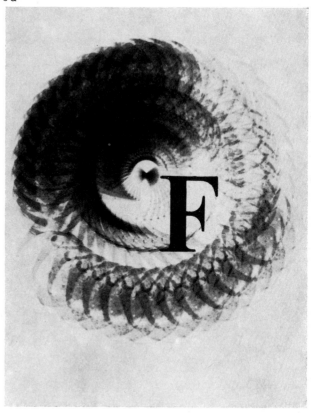

1a         1b

1c

# 9 Patterns

It need not be emphasized that photography is the ideal means, with its facility for unlimited multiplication, for the creation of regular patterns. To produce innumerable rows of copies would, however, be time-consuming, and would also include sources of error that are cumulative. On these and the next pages you can follow the creation of seven different patterns. All examples are based on a graphic negative; Fig. 1a–5a are direct prints of parts of plants, 6a is a photomicrograph of crystals; 7a is a landscape dissolved

1 d

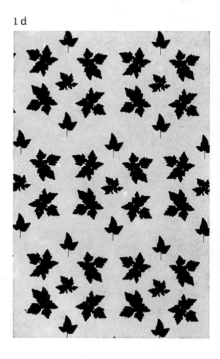

*Just four leaves can produce really diversified patterns, by multiple exposure, combination or repetition of the different photograms.*

1 e

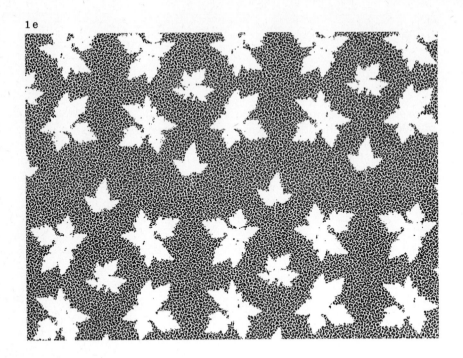

2 a

*Leaves of Acer Japonica,
whose photographs, some
negative, some positive, pro-
duce a pattern resembling
cotton printing. Only skill in
composition is needed here.*

*The two basic elements
(on the right), joined nine
times, result in the pattern
below.*

2 b

2 c

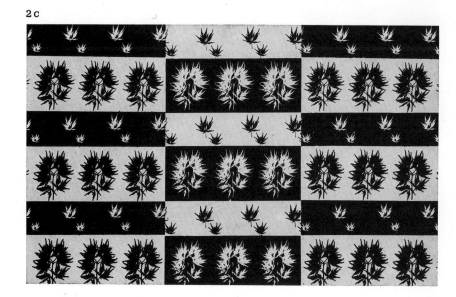

*These patterns give rise to ideas for wall-paper designs, wrapping paper, and textile patterns. The various elements allow many variations, with wide scope for experimenting.*

3 a

3 c

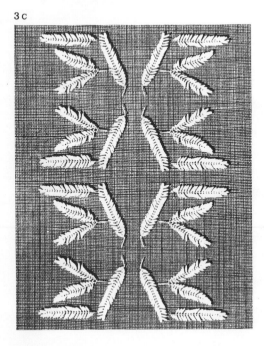

into line contours by solarization. The first step in creating a pattern consists of producing several prints (usually four), which may all be identical (Figs. 1d, 2b, 7c), or half of which may be printed laterally reversed (Figs. 3b, 4b, 5b, 6b). Pasted exactly together, these prints form the basic pattern to be reproduced. The joints, which are also visible, must be blocked out on the film.

This basic pattern can now be manipulated for further multiplication in many ways, i.e. by producing a transparency for an alternative negative picture on a black background (Figs. 2b and c), or by printing it through a screen or fabric structure (Fig. 3c). The latter method was used when a thin negative was printed together

At the bottom of this page is a kind
of cotton print design, familiar in the
German countryside and in Mexico.

3 b

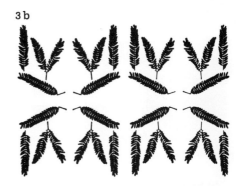

3 d

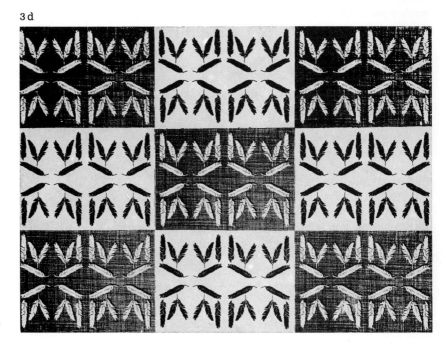

*The basics of designs such as 4b is a simple, clean, original motif 4a; four prints were made, two laterally reversed, and cut and pasted together into a design which was re-copied.*

5 a

with a slightly offset thin positive film through a fabric structure to obtain black shadow contours simulating depth.

This trick, hardly noticeable in the strongly reduced final picture Fig. 3d, is clearly visible in the part picture Fig. 3c. To obtain a certain modelling suggesting embroidery the negative Fig. 3b was printed through a fabric structure. The little leaves were, to begin with, transparent within the tissue. They printed in black. After superimposing the negative Fig. 3b—slightly offset, so that the leaves were not completely in register—only a

narrow, black shadow rim remained, whereas the leaves proper were rendered in white, blocking out both the texture underneath and, in part, also, their own outlines.

Further combinations of new prints produced other variants, linear (Figs. 2c, 4c, 7c), based on regular oblongs (Fig. 2c), or offset oblongs (Fig. 6c), a hexagonal honeycomb arrangement (Fig. 1d),

*A more complicated design, 5b, made up from the re-copied paste-down original 5a.*

5 b

*This pattern of an oriental carpet originated in a macrophotograph of crystals.*

6 b

or a diagonal guide line, which can be the result of a basic pattern, continuing in both directions (Figs. 5a, b).

The examples seen in Figs. 1e and 7d, with the screen printed in, show that after yet another stage of copying the pasted-down originals the final result can, once again, be influenced by further multiplication on large areas.

The picture sequences shown here and on the preceding pages explain the successive build-up of a pattern beginning with the basic picture, which is first copied four times (two pictures normally, two laterally reversed). This primary ornament is now copied. As many copies of the film must be obtained as are required for the production of a strip, which is in turn copied, so that further prints can be obtained from the film for the pasting-down of strip patterns.

The prints must be uniform in gradation and density and a jointless matching of the individual pictures when they are pasted down is essential at every stage. In the first copies minor inaccuracies can still be retouched on the negative. But as the individual pictures add up, becoming smaller and smaller on the negative, retouching will finally be out of the question. At any rate, this work calls for the greatest possible precision. The cut edges of the bromide paper can be dyed with the broad tip of a felt-tipped pen. This makes them fairly inconspicuous in reproduction. Gener-

6 c

*Top: Photograph of a group of trees. In the variants shown here it is developed into a tapestry pattern.*

7 b

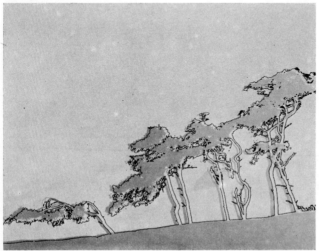

ally, cutting with a trimmer, no matter how sharp, is not recommended, as it cuts the emulsion together with the fibrous paper in a single action; this sometimes causes the emulsion to crumble away.

Better results are obtained with a sharp knife if the emulsion is first lightly scored by hand, and the paper base cut with stronger pressure. Careful rubbing with a pumice stone will remove any fibres left.

*The repeated tapestry pattern was cut and pasted down, with the intermediate joins disguised by the white background.*

7 c

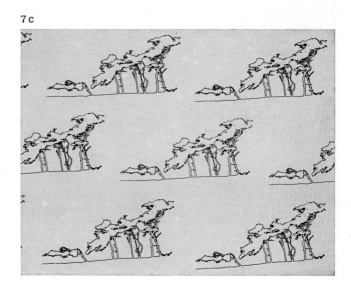

*The tapestry pattern of the design on the previous page can be elaborated further by printing in a delicate fabric texture.*

7 d

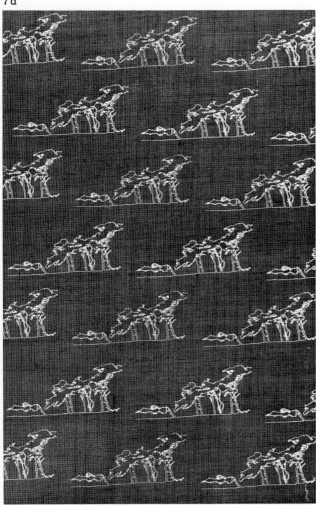

# 10 Introduction of "alien" colours

1 a

*A simple multi-print motif is a good starting point.*

Painting—in the sense of the application of colour—is of course, not only a legitimate method of commercial art, it is part and parcel of it. In photography the subsequent application of colour to a monochrome picture is called "colouring" or "tinting". Because it is unacceptable and incompatible with the technical process of photography, people who claim to have good taste abhor it, and quite rightly so. The answer here is colour photography. But photographics, like the graphic arts proper, is commercial art and may obtain its colours from wherever it

*Here the graphic compared with the ordinary photographic effect is based on the eight repetitions of one and the same directly printed mimosa leaf in a strictly symmetrical arrangement.*

The graphic character is enhanced by the addition of colours. If possible, do not copy nature. Choose at least one "alien" colour (in this case, blue).

*An ordinary photograph, Fig. 2a, was the basis of a coloured bird design.*

can get them. A pattern can be printed in blue, red or green as desired, even if the original is only black and white. A second or third colour can also be introduced into a drawing without difficulty. The only decisive factor is the printing cost.

The combination of black-and-white photo-graphics with colour is justified when the natural, automatically produced colours are to

*The negative was combined slightly off-set with a contact printed positive made from it and printed, Fig. 2b.*

be replaced with "alien" colours to produce an "unnatural" effect as in the examples shown here. The formal reproduction is always a pure black-and-white photographic subject; the colours were introduced at a later stage. Transparent colours are suitable for this purpose. Unlike pigment colours (body colours) they consist of soluble dyes, which are absorbed by the surface of the bromide

*This is a print made from Fig. 2b.*

paper emulsion, and cannot be wiped off.

The colours are not applied at the concentration at which they are intended to be ultimately effective. They are always used at a weaker concentration, and the final saturation is achieved by a repeated build-up. A drop of tint must not remain in a place for even a few seconds. Its complete dye content would otherwise be absorbed by

2 d

*The print, Fig. 2b, was then coloured with transparent photo dyes.*

the gelatine layer of the paper, with the result that the shape of the drop would still be visible through the more intense colour subsequently built up.

It is therefore necessary during overlaying to move the dye on the surface continuously. Only when the dye has been absorbed completely and evenly by the paper should the second application follow to increase the intensity of

113

3 a

*This is a woodgrain negative of a type specially prepared for
combination (sandwich) printing.*

the colour.
This necessary colouring tech-
nique, in which the brush must be
continuously moved across the
entire surface does, however, make
it more difficult to maintain the

contours accurately. This is not so
in the examples shown here,
because the shapes to be coloured
are surrounded mainly by a black
background. "Trespassing" be-
yond the contours does no harm,

3 b

3 c

*A line design made up from an art nouveau drawing, Fig. 3b, and a directly printed photogram of a gear wheel.*

because unlike pigments, transparent colours are invisible on a black background.

The picture sequence Fig. 1a–c shows the build-up of a signet from a single plant leaf, printed four times each, right way and wrong way round, pasted to form an ornament, copied, and finally coloured with transparent colours. The various phases of composition of the picture Fig. 2d

*All three components, Fig. 3a, b and c were combined with lettering to give the effect in Fig. 3d.*

are illustrated by the examples in Figs. 2b and c, based on the photograph Fig. 2a. The negative together with its associated and slightly offset transparency was printed on a new film (2b). The print of this (2c) was then coloured (2d). The photomontage Fig. 3e is composed of the separate negatives 3a (rosewood), 3b (an Art Nouveau drawing), and 3c (a direct print of a gear-wheel). All

printed together produce Fig. 3d. The solarized negative Fig. 4a, which shows the contours of a crane's bill plant as fine lines, was enlarged (4b) and once again solarized. This produced the double contour around the flower bud seen enlarged in Fig. 4c (from top right of 4b). Fig. 4d shows the final result after the text was printed in and colour added.
This is a particularly impressive

*The effect was then coloured with transparent dyes.*

3 e

*A plant picture was solarized at the negative stage to give Fig. 4a.*

example of the photo-graphic artist's need of imagination. He can often derive his ideas from letting small objects such as leaves and flowers strike him as pictures or purely by their contours. If you can completely forget what you are looking at and consider only the shapes as such, ideas will quickly crowd in on you. Here, as in any other field, practice makes perfect. Although the picture shows a genuine bud, its effect is abstract (through alienation).

4 b

The flower bud is the focus of
interest. We pick it (*see below*)
. . . *and then* . . . (*see following
page*).

4 c

*The solarized bud, greatly magnified, coloured and with lettering added.*

# 11 Abstract photo-graphics

1

*Toothpaste rubbed across a glass
plate with the fingertips.*

Every product of photo-graphics
betrays its photographic (in the
conventional sense) origins some-
where. In spite of all alienation
processes and of all the realized
possibilities of stretching, bending,
hardening, and distortion, the un-

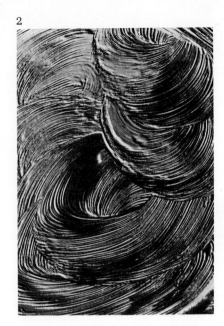 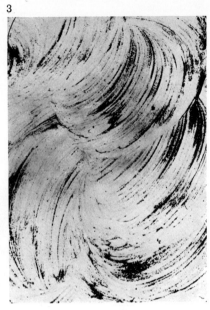

*These plates were placed in the carrier and enlarged, like an ordinary negative. The texture could be thick, Fig. 2, or thin, Fig. 3.*

distorted picture still shows through. In a nutshell, photographics depend on the real original, the object—in spite of every effort to change it.

But there are also innumerable "originals" unrelated to any subject, because in reality such a subject does not exist, but is created only with photographic techniques. Shapes can be produced by accident. A fleeting moment brings about a form that dissolves within the next—transient like the flash of lightning, which cannot be reproduced unless it is recorded in the camera at the instant it strikes. Nor is this the only example. The forces that create forms are many: the water with its ever-changing wave motion, the wind imprinting patterns in the sand dunes, the light with its iridescent play of colours.

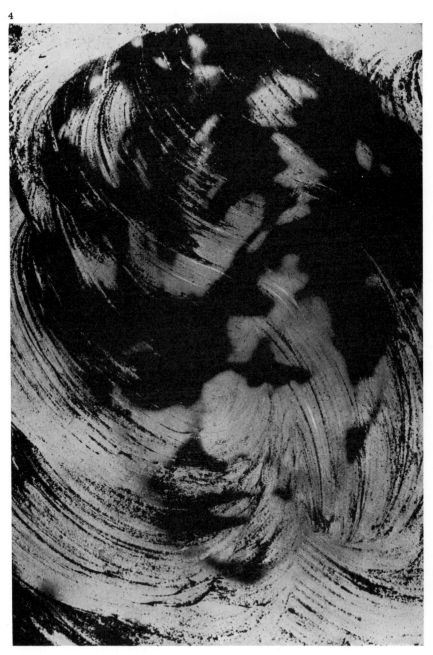

*When combined with a picture the swirls turned an ordinary portrait into a graphic effect.*

*Pure accident decides what shape a wave will assume through reflection at the moment of exposure. It may be picturesque, it may be dull. Its effect varies greatly between the positive and the negative.*

Negative

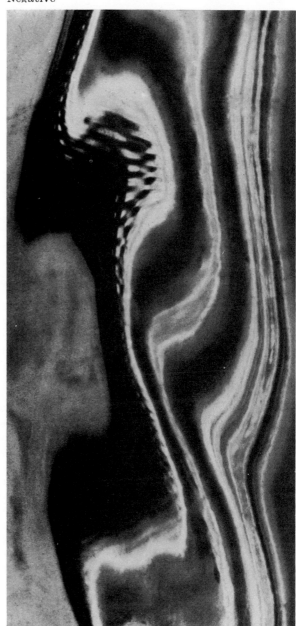

*Here the accidentally
created chessboard
pattern within the large,
soft highlight is a decisive
feature. It is caused by a
lattice fence reflected on
the crest of the wave.*

Shapes appear wherever you look. Then there is, of course, also the artistic prop. One knows how forms can be produced without any opportunity of recording them, and, based on this knowledge, conditions are created to realize them. Here, a comparison to chemistry is perhaps appropriate, which produces, synthetically, substances that spontaneously form in nature.

The pair of pictures in Fig. 5 belongs to the first group; it shows light reflections from the surface of a wave, positive on the left, negative on the right. It has no concrete existence, no presence; although it has form, it is immaterial in the original sense of that word.

Figs. 1, 2, and 3 are also fundamentally immaterial, even if they owe their origin to the previously mentioned artistic prop. In all cases this consisted of toothpaste rubbed with the fingertips on glass plates, which were then enlarged like ordinary negatives. The toothpaste, then, is not perceived as such, (neither as paste, nor as a tube). It is merely a means to an end. It is its constituent, chalk, shaped by the papillae of the fingertips, that becomes visible. In Fig. 2 the application is "pasty", i.e. liberal. In Fig. 3 it is sparing, because the resulting wipe figures were to be printed combined with the negative of a portrait. Fig. 4 shows the effect; the spiral loops of Fig. 3 (used laterally reversed here) almost transformed the purely photographic character of the portrait into a graphic presentation. The colour reproductions, Figs. 9 and 10, show two variants (which can be added to at will) of interplay of light produced on a projection screen illuminated by two slide projectors. Two black-and-white transparencies of circles and a pattern (Figs. 6 and 7) were used as starting points; they were superimposed on the screen and photographed. The various colour combinations depend on the kinds of colour sheet (cellophane etc.) placed over the transparencies. The supporting patterns should as a rule be white on a black background (Fig. 8). On the projection screen they will appear also on a black background, into which the pattern of the transparency in the second projector is projected together with the colour sheet, lighting the blackness up with its own colour.

This technique becomes even more clearly apparent from the components of the transparencies Figs. 11 and 12, which make up the colour picture Fig. 13.

The two pictures on page 130 and opposite were also produced with "creative assistance". Left: Two drops of Indian ink were placed on a gelatine-coated sheet of glass, which was rocked to make them flow; the shapes produced resemble a pair of figure skaters. The other strange creature owes its existence to a drop of Indian ink and an air bubble on a viscous sugar solution, which crystallized

6

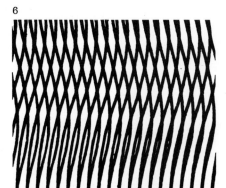

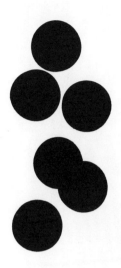

8

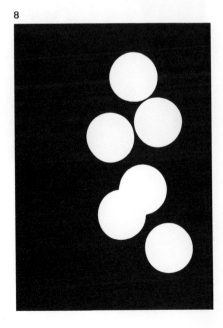

*Simple objects, such as wire mesh or buttons, are eminently suitable basic shapes for varied photographic compositions. They are alienated to the extent that their true purpose is no longer recognizable.*

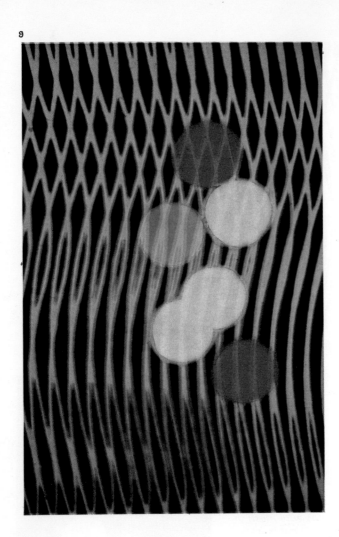

*Colour effects varied at will, using silhouettes of
wires and buttons, and interchanging colour filters
in the two projectors.*

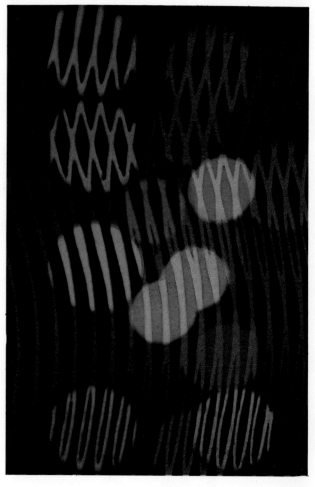

*The shapes projected on the screen produce inexhaustible variations from the coincidence of the coloured light beams.*

in two frizzy clusters on the top. Picture Fig. 14 was created without a prop. A little lipstick was squeezed between two sheets of glass, which were then quickly pulled apart. The tree-like branches formed spontaneously. All you need is ideas, and there are hardly any limits to experimenting with them.

Thus, the observation of a knife-grinding operation was the underlying idea of the lipstick tree-pattern. When the knife was lifted

*Figure skaters created from drops of indian ink placed on gelatine-coated glass and spread. And in the other case from indian ink on a sugar solution.*

**11**

**12**

The colour picture on the facing page
is based on these two black-and-
white components—it is an interplay
of light (see more detailed information
on p. 126).

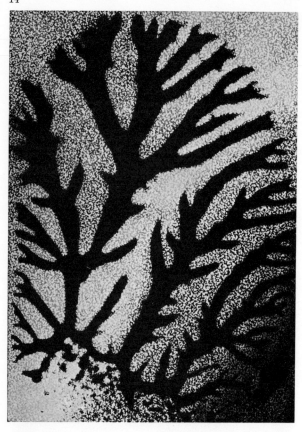

*Lipstick was squeezed between two sheets of glass which were then pulled apart to give the pattern shown above.*

from the stone, the scraped-off, moist grindings contracted into branching figures depending on whether the knife edge was lifted quickly or slowly. Naturally they were not so clearly visible as in the version shown here, since the tonal difference was only slight.

# 12   Graphic colour transparencies

*Negative of a colour transparency printed on orthochromatic graphic arts films.*

1

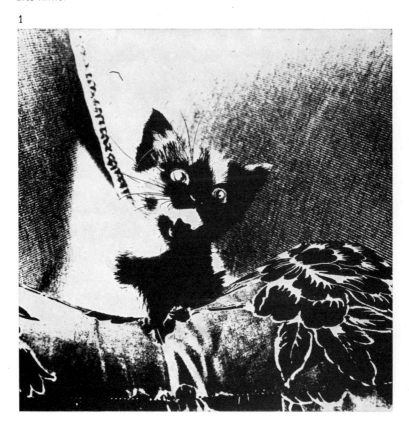

*Second copy of the negative in Fig. 1 printed on graphic arts material through a strip of cloth.*

Colour photography, an achievement, for practical purposes, of our century with few to rival it, suffers—the longer we engage in it—from increasing perfectionism. Its absolute realism denies it the status of a work of art. It reveals the photographer's imprint far less than a black-and-white photograph, in which the creative intention of the artist is more easily recognized because the omission of colour transposes reality and converts it into a personally con-

3

*When the Fig. 2 picture was mounted in exact register with the original colour transparency the result was as shown above.*

ceived work.

In colour photography the surroundings are reproduced exactly as they are. Except for the absence of the third dimension, the colour photograph is a likeness of reality in which even the sky is rendered in its natural blue and translucence. A comparison with "canned reality" is therefore not at all far fetched.

This, incidentally, explains the multifarious efforts to "denaturize" reality.

137

We are now introducing three methods which, starting from ordinary colour reversal transparencies, permit the insertion of additional accents at a later stage.

Everybody knows the effects produced when two colour transparencies are superimposed—provided they are not so dense as to be opaque. The clear shapes disappear, are replaced by unreal structures, and new colours are created. By and large such sandwiched slides must be regarded as no more than playful results unless, of course, a unifying thought of ultimate combination existed already when the pictures were taken.

In the examples shown here the colour transparencies were sandwiched with black-and-white positives or negatives; the latter were obtained from the colour transparencies themselves.

Figs. 1 and 2 show the black-and-white contact prints to be made; combined, they produce Fig. 3. Fig. 1 shows the negative obtained from the colour transparency and printed on orthochromatic graphic arts film. Fig. 2 shows a second copy of the negative Fig. 1 on graphic arts film through a strip of cloth. The structure of the fabric therefore appears only in the dark portions whereas the bright ones (dense in the negative) remain unaffected. This film—a black-and-white transparency—mounted in precise register with the colour transparency produces Fig. 3. The areas surrounding the highlights are shot through with a fabric texture.

Here is an example that shows that even the common, hackneyed subject of swans on the water can acquire a more original note through the sandwich method. A negative was contact-printed on graphic arts film; it was hard and dense, so that all detail in the plumage of the swans disappeared (Fig. 4). Fig. 5 shows the transparency obtained by printing the hard negative once again. From the transparency another negative, not shown here, was obtained, but unlike that in Fig. 5 it was only thin, displaying little density.

The purpose of this more complicated negative production via an intermediate transparency is this: only when the highest possible density is aimed at can fine details be made to disappear in the highlights (see Fig. 4, in which the swans are shown as pure silhouettes). But only silhouettes lack detail completely and therefore consist of uniform areas. Were the required thin negative obtained instead at the first contact printing stage, one would have to manage without this uniformity of tone. The brighter areas would still retain a trace of detail. But these totally detailless grey areas are a rather important factor in the "denaturizing" idea. They are visible through the colours in Fig. 6. It will also be noted that they do not precisely match the colour picture. The two films are slightly

4

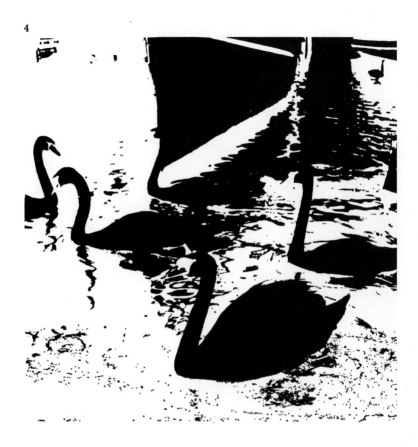

*A negative printed on graphic arts material to eliminate all detail in the plumage.*

displaced relative to each other so that they form both transparent (white) light and opaque (black) shadow rims. This discrepancy of the contours, as well as the presence of a uniform, neutral grey tone, create that lack of realism suggesting a fairytale atmosphere. The basic motif of Fig. 9 is the reproduction of a design on a white early 19th century coffee pot. The surroundings of the hard negative obtained from the transparency were com-

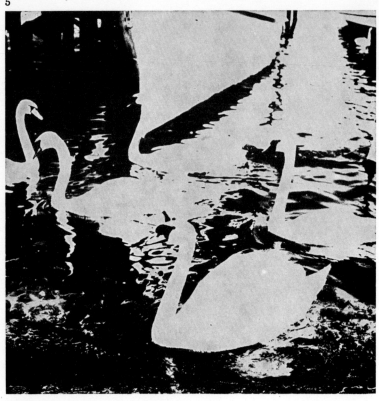

*Positive made by contact printing the hard negative, Fig. 4, once more. A thin negative was then made from this.*

pletely blocked out with black dye so that only the sprig of flowers as a line reproduction remained visible. Fig. 7 shows a print of it. Being printed once again on hard film it produced the picture Fig. 8. At this stage the word DONNA was printed in. In conjunction with the colour transparency this film, with its large areas of pure, opaque black, took on the function of a mask. A blue transparent sheet was placed under the text and the pattern of the sprig of

6

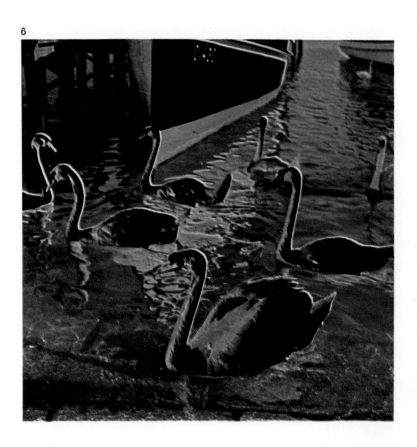

*The thin negative was then bound up slightly out of register with the
original transparency to give the vigorous effect above.*

flowers stuck down behind it with
cellulose tape in a slightly offset
position. This produced the partly
transparent, white rims. In the final
result in Fig. 9 the contrasts are
intensified by additional blacks.
The out-of-register effect produces
the unrealistic appearance.

This technique can be further
varied or developed to show other
effects. Thus two identical colour
photographs can be taken, with
only the colour of the illumination
or the angle of incidence of the

7

**DONNA**

*A basic design was copied off an old coffee pot.*

light changed, e.g. one picture is taken in blue, the other in orange light. After the superimposition of the films a completely new colour effect appears, and continuously changes when the pictures are displaced relative to each other.

The subject in Fig. 7 was printed on contrasty film.
Now we can tackle our intended photo-graphic
picture in colour. The text is backed with blue
transparent sheeting, and the sprig of flowers . . .

*. . . is secured behind with tape, but slightly displaced.*
*This produces a pseudo-plastic effect with a character of*
*its own.*

# 13 Exposure and printing montage

1

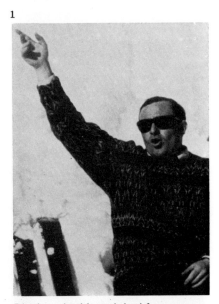

*Black and white original for combining with the colour transparency.*

Exposure and printing or enlarging offers further scope for photo-montage impossible to achieve with scissors and glue. This applies, for instance, when soft contours have to be preserved or portions of the pictures are to overlap so that one is visible through the other.

For the result, see the colour picture on p. 145, the term "montage" is not quite appropriate. This, incidentally, applies to all exposure montages, although these, too, consist of two or more components. Our colour picture on p. 145 is made up of the expo- in Fig. 1 and the ultra-hard en- largement in Fig. 2 obtained from it, and a brandy glass. The black-and-white photograph merely forms the background in front of which the brandy glass has been set up. Illumination of the background with blue-grey light aims at an impression of the atmosphere of a chilly evening, with which the

2

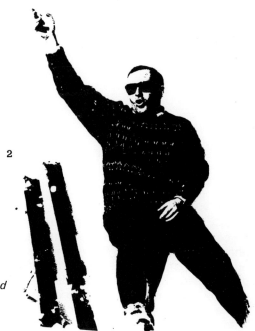

*The snapshot in Fig. 1 was enlarged on extra-hard material simply as a background to the colour transparency of a brandy glass.*

4

5

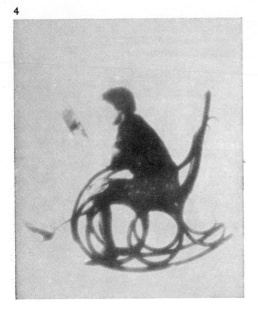 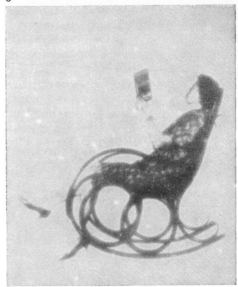

*Two and more photographs, combined, lead to "movement", made in this case from two extra-thin negatives.*

brandy glass contrasts.

Fig. 6 is an example of the previously mentioned overlapping. It is composed of the movement phases in Figs. 4 and 5. For the purpose of montage these component negatives had to be developed so thinly that no appreciable densities were produced. They became evident only in those picture areas (especially in the framework of the rocking chair) which were superimposed during both movement phases, whereas all other details remained more or less grey. For enlargement, the transparencies were mounted on top of each other with adhesive tape so that the curved support of the rocking chair was precisely

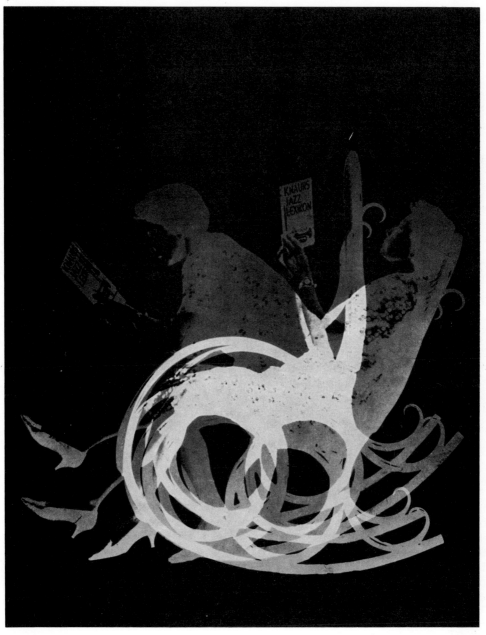

*Telephone, which, when combined with another negative in the simplest way adds a new dimension or significance.*

superimposed.

The simplest case of effects obtained with the joint enlargement of two superimposed negatives is illustrated by the comparison pictures in Figs. 8 and 9. They are both produced from the same photograph, Fig. 7, which shows a very prosaic telephone handset. The same negative was enlarged once through a rain-spattered sheet of glass (Fig. 8) and then again through a cloud negative (Fig. 9). In spite of the primitive nature of this technique the purely objective picture Fig. 7 now comes to life. Fig. 8 suggests a function: "Emergency Call", whereas in Fig. 9 the receiver appears to have been carried away to great heights or far distances, with the connotation of a long-distance call.

The masking technique is a good aid to finding a basic composition. You can easily determine the pictorially most favourable position or section of the negative by adjusting the picture under the mask.

Masking, too, falls under the heading of print montage. Figs. 10 and 11 are examples of this method. Mask Fig. 10 was produced by direct exposure of a pistol placed on a sheet of process film under the enlarger. Through this mask, which had to be developed to a great density, any negative (here a hand lighting a cigarette) can be printed or enlarged. The same technique was used for the picture below. If the mask is dense enough there is no danger of

*A mask can be produced by a photogram on contrast material. It can be combined with a negative to give the effect show here.*

14

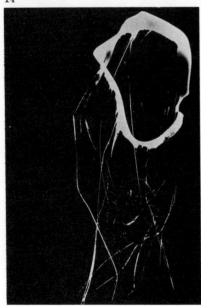

portions of the printed-in picture coming through and appearing as faint traces on the white paper background.

The "unreal" montage composed of the films Figs. 12 and 13 printed together was produced only for the purpose of composition. The individual negatives consisted of a direct print of book cloth (Fig. 12) which dissolved into threads on being heated. While they were being enlarged together, twelve little coins were lying on the bromide paper (Fig. 13).

Some of the coins could have been removed after half the exposure time and the exposure continued— thus introducing grey tones into the picture at will.

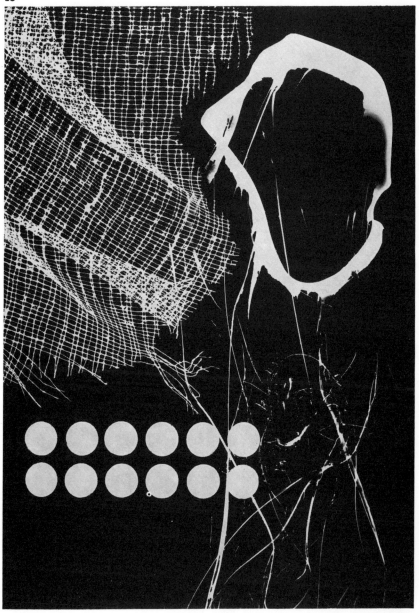

*Compositional design formed from the components shown opposite.*

# 14  Mechanized drawing

Photo-graphics have a style of their own, often quite unmistakable and unique. On the one hand they flirt with photography, on the other they have a strong affinity with pure commercial art—drawing. To this affinity with drawing the photographic techniques offer an additional, valuable aid—the photographic "sketch" as original or drawing copy. Just think of how many hours you would have to spend on drawing the picture in Fig. 3 by hand.

*Photography can be a very handy labour saving device. A "drawing" was obtained by printing a photograph, Fig. 1, on hard material and blocking out unwanted areas.*

1
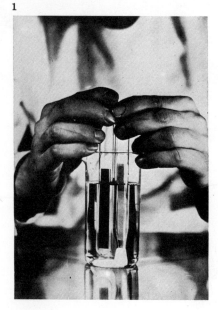

2
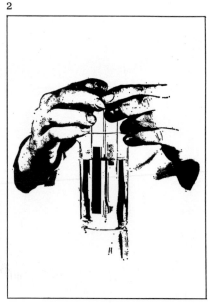

3

The graphic image opposite was combined with an abstract colour pattern by photographing the pattern through it, unsharp.

*Colour transparency, Fig. 4, printed as Fig. 5 lent itself to colouring in a way that avoided the mundane "catalogue" appearance of the original.*

It is simpler with the camera. A photograph (Fig. 1) is printed so hard on process film that it assumes the character of a line drawing (Fig. 2). This film is now placed on a sheet of glass, and an unsharp background photographed through it on colour film, so that the colours appear blurred. That is all. Fig. 5 is a contrast print of a colour transparency (Fig. 4), reproduced in black and white. Colour photographs of this kind cannot quite rid themselves of the association with a flower catalogue. The hard, i.e. alienated, black-and-white print, however, can serve as a basis for a stylish application of "unnatural" colours. Figs. 6, 7, and 8 are examples of how photographic techniques can be used as a timesaving aid to drawing. The contours of a negative (Fig. 6) are traced on paper

**6**

**7**

**8**

*The contours of a photo, Fig. 6, were traced round with a felt tipped pen,*
*Fig. 7. The result could be contact printed many times or reversed, Fig. 8.*

159

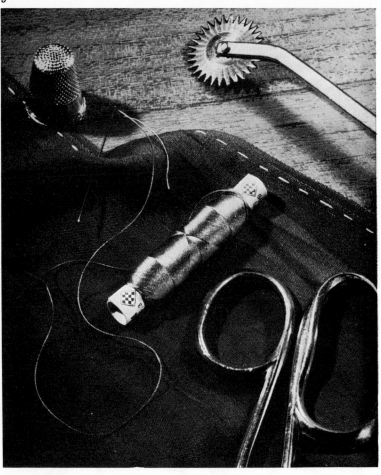

*Basics of a more detailed hand drawing. A very pale enlargement was made from this.*

with a felt-tipped pen under the enlarger (Fig. 7) and the result is copied. Any number of prints can now be pasted next to one another at increasing degrees of enlargement (as well as being laterally reversed, Fig. 8).

Fig. 10 is a real hand drawing, for which the original photograph in Fig. 9 was the basis. A weak, grey enlargement of the photograph is made first, and a line drawing made on it in Indian ink with a soft pen (to avoid damage to the emulsion).

*The weak image was drawn over with indian ink, and then the
residue silver image obliterated by reduction.*

The photographic silver image is
now removed in a bath of Farmer's
Reducer and dried after the usual
rinse. Obviously great care must
be taken not to smear the ink
drawing on the wet support;
generally, however, it adheres to it
well. Real danger exists only with
large expanses where the black
film cracks on the swollen gela-
tine base. Such areas are therefore
painted over only after the emul-
sion has become dry again.

Photography is an efficient aid to

13

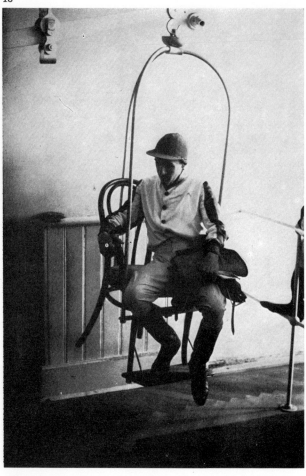

*A photograph may be specially taken to form the basis of a drawing, or existing pictures may be suitable, however cluttered the background may be.*

pencil drawing, too. As long as a negative and an enlarger are available, pencil drawings can be produced without any further assistance. The negative is inserted in the negative stage of the enlarger and projected on a sheet of drawing paper in the masking frame. The bright portions of the projected negative image are now hatched with the pencil until the differences in tone are eliminated. Room lighting is of course turned off during this operation. When it

14

*The negative was placed in the enlarger, projected on the baseboard and drawn in, simplifying the whole effect.*

is turned on again the paper shows a positive drawing (Fig. 14) according to the negative of the photograph (Fig. 13). The photographic example Fig. 15 shows a radical graphic modification of the Fig. 16 photograph. This was not only reduced until a pure black-and-white effect was obtained; a new background was also mounted in the right-hand third of the picture. Contours lost during hardening had also to be restored by drawing them in.

15

**16**

*A motif popular in advertising.*

*The graphic reproduction in Fig. 15 required changes of background detail and the reinforcement of some contours with handwork.*

*The examples in Figs. 17–24 show various stages in de-registering and screen effects obtainable with quite simple originals.*

The following pages illustrate variations on a theme. Figs. 17 and 18 show the original negative, and a transparency made from it. Further prints on film through a line screen were made from it (Figs. 19 and 20), one right-way-round, the other laterally-reversed. The other representations were produced by combination of these films with each other; some of the films superimposed in precise register (Figs. 21 and 22), some mutually displaced (Figs. 23 and 24), had to be enlarged together. Thus not only different line directions, cross screen and point screen areas were obtained, but also pseudo light-rims and cast shadows.

The pictures shown here by no means exhaust the possibilities of variation.

**17**

**18**

**19**

**20**

**21**

**22**

**23**

**24**

# 15 Mounting montage

*An engraving, drawing or other such picture can be artfully combined with a photograph if the perspective and scale will correspond.*

If part of a drawing has failed beyond redemption, an expedient is used: fresh paper is pasted on the area of the failure and the detail in question redrawn on it. In line reproduction the pasting will be quite invisible.

In half-tone originals, however, such radical cures are not possible unless the pasted areas noticeable along the cut edges are meant to be noticed. In the so-called collage visibility of joins is ignored because the contrast between

3

*Fig. 4 and 5 are the two basic photographs from which the montage effects opposite were derived.*

adjoining picture elements is deliberate.

But when montages are mounted it is sometimes necessary for this process to be invisible. Not so in the example shown as Fig. 3, composed of a copied "Fin de siecle" xylograph and a real photograph (Figs. 1 and 2). Irrespective of how the combination was achieved, a montage of two different reproduction techniques is evident at first glance. So is the intention of this montage in the

*It was only necessary to tear one of the enlargements, Fig. 5, in this case, and paste the halves over the other picture.*

final result. The photographically prosaic landscape surrounding the young maiden of the Eighties particularly emphasizes, without any rupture between the two techniques, the dreamy expression of longing. The background does not impress the viewer as a strange intrusion. It even emphasizes the hand-drawn representation in the foreground.

Two versions of the simplest kind of mounting montages are shown in Figs. 6 and 7. The typewriter

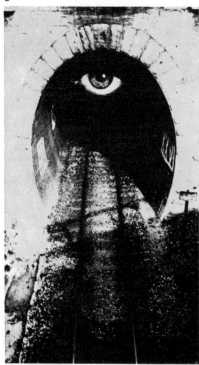
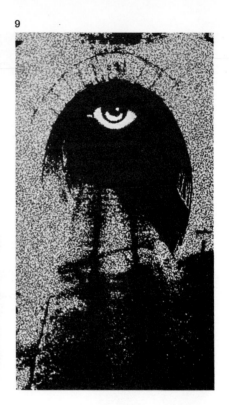

*A granular screen is very useful for disguising the joins in montages.*

(Fig. 4) and its carrying case (Fig. 5) were photographed in the same place and in the same position. Two dimensionally identical enlargements were made. All that had to be done then was to tear the enlargement Fig. 5 diagonally in halves, and to paste the halves over the enlargement Fig. 4. Contents and carrying case are now reproduced simultaneously. The white paper base separated from the emulsion and running diagonally through the picture is by no means disturbing (Fig. 7). On the contrary, it reveals the intention.

A granular screen is useful if irregularities are produced during mounting which might make the manual interference visible. When it is included in the printing, it dissolves the detailed rendering and obliterates undesirable lines (Figs. 8 and 9).

# 16 Abstract forms

When your television set gives you trouble you might at least enjoy the very graphic impressions flickering in rapid succession across the screen. Figs. 3 and 4 show two such decayed pictures. Photographing them presents no problems. The camera, loaded with fast film, is mounted on a tripod and focused on the television screen. The lens is stopped down to $f$5.6 and a shutter speed of 1/30sec selected. Higher shutter speeds are not suitable, because the pictures obtained would not be complete, since the individual pictures are completed (being built up from lines) at a rate of 25 per sec.

The negatives will be rather flat

*A comb was drawn across a soot-covered glass plate and the result enlarged to give the effect in Figs. 1 and 2.*

1
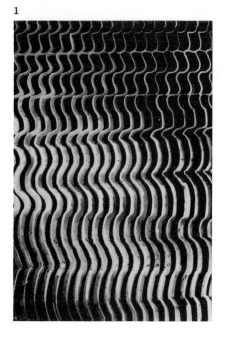

2
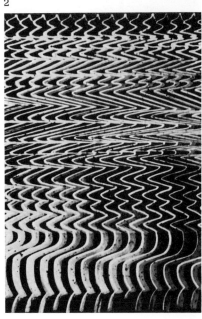

*Interference on the television screen can be photographed and printed graphically as a design.*

and lacking contrast, but you can increase this in the usual manner by copying the negative on contrasty film. At the same time the individual lines, which emphasize the graphic character, will be clearly brought out.

Soot and adhesive are other suitable media with which much can be done in the field of photo-

graphics. You can coat sheets of glass with soot by moving the sheets to and fro above a candle flame. The soot will adhere only lightly to the glass and can be easily removed. In the examples, Figs. 1 and 2, a comb was drawn across the layer of soot in various directions. The result was then enlarged on hard paper. Other patterns can be produced if a few teeth are missing in the comb, or if a hairbrush, a stiff broom, corrugated cardboard, or the edge of a carpet is used instead. The attraction of these patterns with all their regularity consists in the accidental irregularities produced quite spontaneously. The narrow grooves sometimes become wider

*A "painting" of transparent adhesive on glass printed in com-*
*bination with a wave screen, Fig. 5, A negative and positive*
*transparency made from it were placed together and enlarged,*
*giving the effect in Fig. 6.*

when soot has accumulated on the teeth and in turn removes more soot from the glass plate. Or the comb bends slightly, so that not all the teeth touch the glass surface, etc. Many puzzling effects can also be obtained with transparent adhesives. In the simplest case you "paint or draw" as you wish directly from the tube onto a sheet of glass. Glass-clear adhesives have a high light-refracting power, so that they produce optical effects. As soon as the adhesive has set, the glass plate is inserted in the negative stage of the enlarger. The initially invisible patterns will be seen as soon as the enlarger lamp is decentred, i.e. moved sideways from its central position. Fig. 5 shows such a "painting on glass", enlarged together with a wave screen.

By the combination of a negative with its associated transparency the peculiar plastic effect of Fig. 6 was obtained.

A

SIGNAL

B

SIGNAL

*These two, positive and negative, are the first stages in the type
distortions opposite and on the pages that follow.*

The clear, straightforward print, Fig. A, of the word SIGNAL is the starting point for the variants shown in this chapter. It was reproduced on line film, resulting in the negative, Fig. B. A transparency was made of this, corresponding to the original print A, but differing from it in that the black lettering is not on a white paper base, but on transparent film. In a second definition we must regard A as positive film, in the same way as B corresponds to the negative film. The variants shown here are paper prints.

Figs. 1 and 2. Instead of enlarging the negative B in the usual way, place the paper at an angle to the enlarging lens. In Fig. 1 the letter S is nearest to, the letter L furthest away from the lens. As the word is being read the size of the letters decreases as does their distance

**1**

SIGNAL

**2**

SIGNAL

**3**

**4 a**

SIGNAL

**4 b**

SIGNAL

**5**

from one another and their distortion.

The same applies to Fig. 2, where the obliquely positioned paper was, in addition, curved in an S shape. In enlarging, the depth of focus is very shallow. With the letter S in sharp focus, the letter L would be unsharp and vice versa. In both examples, the focus was on G and the lens completely stopped down. The depth of focus thus accommodated the entire subject to the left and right.

Fig. 3. If the negative Fig. B is enlarged together with a sheet of ripple-moulded glass, the contours of the letters disintegrate according to the structure of the glass. The negative is placed on the glass, however, without being in direct contact with it, but at a certain distance, in the negative stage of the enlarger. It is enough to separate it with two pencils as spacers. Both during focusing and stopping down the character of the letters changes either in favour of the structure of the glass or of the sharp negative. It can thus be varied at will.

Figs. 4a and b were obtained by enlargement of the films with the lettering together with screen foils, here in direct contact. Fig. 4a is the result of negative Fig. B through a line screen; Fig. 4b is an enlargement of transparency A combined with a screen of the grain of a piece of wood. Countless variants can be produced depending on the pattern of the screen or texture negative used.

Fig. 5 required the exposure of an additional film. The film Fig. A was printed in contact with a sheet of Japanese rice paper, resulting in a new negative, which shows a negative lettering on a patterned background. The positive film Fig. A was then once again placed on this new negative, but so that the letters were not completely in register. The white (negative) lettering is thus preserved, but a kind of cast shadow appears, formed next to each letter by the newly printed film. The three-dimensional effect can be varied. The impression of high or low type is created depending whether there was much or little mutual displacement between the two films.

Fig. 6 also shows "three-dimensional" letters, but with bright light rims on the left in addition to the cast shadows on the right. Neither one nor the other is present on the two films used. They are the result of super-imposition and displacement of the two films. To produce this effect two new films must be made of A and B. They must be thin, i.e. translucent. This is achieved by processing in very dilute developer; the films must be grey only. During superimposition the grey values add up on one side. During enlargement they form the light rims, whereas the black shadows occur on the opposite side, and where the two films are transparent.

Fig. 7. Whereas in the previous

180

**6**

**7**

**8 a**

**8 b**

SIGNAL

SIGNAL

**9 a**

**9 b**

**10**

SIGNAL

181

*One type of modification can give birth to another. Fig. 11 is based on Fig. 8a; Fig. 12 originated from Fig. 11 but with handwork; Fig. 13 was based on the original but involved a reflection; for Fig. 14a, Fig. A was shot through a glass brick and Fig. 14b was a modification. The other two examples were reflections on oblique surfaces.*

example the letters seem to have a smooth surface, the present example conveys the impression of bent or curved letters. For this effect, too, two new films must be made of A and B. As in Fig. 5, A is first copied together with a half-tone pattern. Film B, too, must be copied together with a pattern, which, however, must have a screenlike texture (cross line screen, dot screen, fabric struc-ture, etc.). During superimposition the individual elements become smaller where the light rims form, whereas they move closer together on the other side in the black areas. Thus the impression of convex letters is created.

Figs. 8a and b are the result of printing the film Fig. A and solarization. The film was not completely developed but exposed to white light after half the

14 a

14 b

15

16

developing time had elapsed. Thereafter the portions that had hitherto remained white were also blackened. Only a white outline remained around the letters as shown in Fig. 8b. A print from it produced Fig. 8a.

The same applies to Figs. 9a and b. These, too, were produced by solarization. Here the film with the fine fabric texture was the starting point, which also gave rise to the convex figures in Fig. 7. The fine lines that formed around each tiny screen element are clearly visible. They give the impression of a mosaic.

Fig. 10 shows the combination, i.e. a joint print of films Figs. A and 8a mutually displaced, described under 5, 6 and 7.

Figs. 11 and 12 are composed of two identical films corresponding to Fig. 8a. In Fig. 11 the contours

*The word, on film, was backlit and reflected on the surface of black glass placed in front.*

17

are merely mutually displaced. Fig. 12 is based on an identical second print of Fig. 11, except that the fields on the right were covered with black dye. This is the only one of all the examples shown here which included manual work. All the others were the result of further photographs. Film Fig. A, for instance, was exposed through a glass brick, resulting in the distorted picture Fig. 14a. In Fig. 14b the negatives of two such pictures are printed together.

In Figs. 15 and 16 the film Fig. B was projected onto oblique surfaces (first sharp, then unsharp), and the projected images photographed.

For Figs. 13, 17, 18 and 19 the film Fig. B had to be backed with a piece of matt sheeting before the letters (which were lit from be-

18

*A "projected" image blurred with cigarette smoke.*

hind) could be reflected in a sheet of black glass placed in front of them (Fig. 13). A sheet of ripple glass covering the black glass. resulted in Fig. 17. Damp, wavy cellophane led to the Fig. 18 effect. The "cloud projection" Fig. 19 is self-explanatory if you turn the picture upside-down. The rays were incident on black paper, and cigarette smoke blown into the picture area produced the light tracks.

# 18 Safety through line originals

Advertising photographs are not published in their original form. They are reproduced via a block, intaglio etching, or by offset printing. The work required on it may improve or impair the quality, especially with deviations from conventional practice. One of the essential points is that the block-makers should be supplied with originals that cannot be altered in process engraving.

In this context line originals are safest, because in reproduction they appear exactly like the original. What the process engraver achieves with his taking screen can be anticipated with so-called copying screens, when the final effect can already be seen on the

*Screen of the type used for the line effect on Fig. 3, made by copying a hard parallel-line screen slightly out of focus.*

1

Hudson

Hudson Pasalong. Diese Feinstrumpfhosen gefallen mir: Ich kann mich frei und unbefangen bewegen. Sie sind bequem anzuziehen, praktisch – ohne Gürtel zu tragen, hervorragend im Sitz, elegant und sicher. Ich fühle mich wohl in Hudson Pasalong.
Neu:
Perfekter Sitz durch drei Dehnungszonen.

Hudson
**Pasalong**
So werden
Beine
bis zur Taille
schön

Perfekter Sitz
durch drei
Dehnungszonen

*Advertising picture for art printing. The fine dots will reproduce satisfactorily on paper with a smooth surface.*

original. The special printing screens required for this are available in cross- and line-structure. Unfortunately they are rather expensive.
The effect that can be achieved is shown here with line screens, which produce an enhanced graphic effect. Such screens con-

3

# Hudson

Pasalong Feinstrumpfhosen

sist of unsharp, blurred lines, see Fig. 1 (strongly magnified). They are easily made—simply by photographing a line screen or regular line pattern out of focus.

The original film, printed together with such an unsharp screen, produces an original which can be printed directly as a line subject.

*This kind of line treatment will print satisfactorily on even the roughest newsprint.*

The half-tones are converted into narrower or wider lines by the combination of the densities in the unsharp transitional regions as the comparison between Figs. 2 and 3 shows. This impressive effect is particularly prominent in Fig. 5, printed, unlike Fig. 4, in line technique.

*A common-or-garden photograph . . .*

5

*. . . printed through a printing screen becomes a graphic subject.*

This is what happens: on the contrasty film required for this method the soft transitions of the unsharp screen add up with the superimposed picture contours to further densities, so that in the contrasty reproduction the bands appear as tapering lines.

# 19 A simple photographic darkroom

The practical means necessary for processing photographs is outlined below. Very simple means can be employed, at least at the beginning, with excellent results. The experience gained will certainly prove very useful if you finally decide to set up a darkroom. The materials necessary for the production of photo-graphics are also discussed.

The commercial artist needs light; without it he cannot draw. The photographer needs it, too; without it he cannot take photographs. The practitioner of photo-graphics shuns it.

His abstract patterns are created away from bright light; but this does not really call for a real darkroom. All he needs is a little space, a corner in which he can spread things out, because the dishes for the photographic solutions cannot be stacked like drawings. They must be arranged side by side, and their dimensions depend on the format of materials to be used. Large formats require large dishes, of which three are usually needed. An example: If the $18 \times 24$cm ($10 \times 8$in) format is used (this is as a rule large enough), a bench area, if possible about $40 \times 80$cm ($16 \times 32$in), must be available to accommodate three dishes: developer, stop bath, fixing bath from left to right. A shallow $18 \times 24$cm ($10 \times 8$in) dish serves for the developer; for the two other baths it should preferably be larger, e.g. $24 \times 30$cm ($12 \times 10$in), and deeper to hold more solution; both the stop and the fixing solution will then become less quickly exhausted.

The table with the dishes is set up in a suitable corner; but the solutions they contain unavoidably spill on the table and floor where they can leave nasty stains. There is a very simple remedy for this.

A frame is made up from strong strips of wood; its internal dimension should be about $35 \times 75$cm ($14 \times 30$in). Soft plastic sheeting that should protrude beyond this frame is placed over it; so that a kind of trough is formed inside for the dishes to stand in. Whatever spills over remains in this trough, and the plastic sheet, gripped at the four corners, can later be removed like a bag and its con-

tents discarded.

Next to this bench should be a space for the enlarger which must be readily accessible. It should not be in contact with the "wet bench". For the purposes of photographics a printing frame for making contact prints is required in addition to the usual enlarger with baseboard and masking frame.

## How to darken the darkroom

As the work is carried out only under suitable illumination daylight must be excluded from the room. Drawn blinds are adequate for darkening the room if, in addition, working is restricted to the evening. Total blackout is by no means essential. The graphic arts films used are no more sensitive than bromide paper. They can both be employed in exactly the same way.

The darkroom is lit according to instructions (provided with the materials used) with a bright red, orange yellow, or pale green lamp near the developer dish. This light should above all make the developer dish clearly visible so that the progress of image build-up in the picture can be observed. Although, generally, the developing time recommended for a given film should be adhered to, it is preferable to be able to watch the film during development, particularly when special variations are intended or corrections made to slightly irregular exposures. Both adjustments are learned from

experience. After development the films (or papers) are briefly rinsed in the acid stop bath to neutralize the chemical activity and then transferred to the third dish, which contains fixing solution. There they must be agitated for a few seconds at first, before being left to fix. The coloured light from the lamp must therefore also light this dish, so that you need not fumble in the dark and risk damage to the films or splash fixing solution about.

## Bath tub, washing line, laundry pegs

After they have been fixed for about 8–10 minutes the prints (or films) must be rinsed for 30 minutes. For this the bath tub with its large volume of water is suitable. But the material should not be carried to it by hand, because the dripping fixing solution leaves nasty stains on the floor, the nastier the more exhausted it is. If no additional dish is available for transferring them, allow the material to drain into the fixing dish first, then place it on an old newspaper, and carry it into the bathroom.

Finally, the films and papers must be dried. This, too, is best done in the bathroom, above the bath, into which they can drain. A line is fixed between two hooks, and the materials are suspended from it with laundry pegs gripping the corners of the sheets to allow the water to drain off the opposite corner.

Films must not be removed before they are completely dry. Papers, on the other hand, should not be allowed to dry fully, because they curl and may become hard and brittle, when it will be difficult to flatten them properly. If two papers of equal size are suspended back to back from a peg they support each other and therefore curl less; in addition, you can dry twice as many prints on your length of line. The curvature of the paper base produced during drying can easily be removed: pull the print across the edge of a drawer, starting with the four corners. Drawers, because they are often opened and closed are free from ridges and are therefore particularly smooth.

This brief description of requirements for a primitive photographic workroom shows how you can make do even with simple equipment, and with relatively little outlay. Once photo-graphics take up a larger share of the commercial artist's activities it is time to plan a special room with more sophisticated facilities.

## Materials for photo-graphics

Looking at photography, one gains the impression that films have to be very light-sensitive, whereas papers are far slower. This is correct within the framework of general photography. But the films used by most amateurs for taking pictures are not the only ones; there are materials for other purposes—for research, reproduction and recording, for the printing trade etc. The last-named films particularly, are also suitable for photo-graphics.

Here are their characteristics: The graphic-arts photomechanical films as they are called are available in several versions, as 35mm films (for recording) and as cut films—also called sheet films—in all conventional large formats. Block makers prefer the faster graphic-arts films in their process cameras. Less sensitive films are used for contact work in process engraving. They share characteristics with hard bromide papers except that the light-sensitive emulsion is coated on a transparent film base. They are accordingly marketed in almost the same quantities and formats as bromide papers.

Their labels describe them as either ortho- or panchromatic or blue sensitive; in addition, they also state the thickness of the film base. Whereas ortho and pan materials must be processed in red or dark green light the blue sensitive (or 'ordinary' film as it is sometimes called) can be exposed to the much brighter orange light and can therefore in practice be treated like bromide paper.

The main feature of these films is their very hard gradation (undesirable in ordinary photography), and that hardness can, in fact, be further increased by development in a specially contrasty developer. The aim, ideally, is to have pure blacks, pure whites, and elimination of all the half-tones

from light grey to dark grey, which are characteristic of photography. For graphic-arts films a graphic-arts developer (recommended in the instructions accompanying the film) should therefore be used. This combination of film and developer is designed to produce the greatest possible contrast (i.e. effect of black and white without transition).

## Developing and printing

Development differs from the normal process particularly when a screen has been used in printing. The screen structure takes something away from the expected density, breaking it up with its lines or dots. Seen from a distance, a screen-textured area always looks grey. Even prolonged development does not change this. But it is important that under the magnifier the exposed parts of the picture be completely black and opaque, pin-sharp and contrasting without transition with the unexposed areas which should be completely clear.

In photo-graphics, grey tones are mainly broken up into black dots, lines, etc. rather than represented by uniform areas.

The ideal negative for this technique therefore consists only of dense, opaque, and of glass-clear portions.

Correctly developed and exposed, a copy of a newspaper page, for instance, is a clear black-and-white picture of the print without the texture of the rough paper on which it is printed. All that is left of the photograph is a silhouette of the densities. And that is how it should be.

Graphic-arts films are available on bases of different thickness, ranging between 0.1 and 0.4mm, like photographic papers, which can be bought in single weight and in double weight. Thin base is particularly suitable for montage negative sandwiches, when several films have to be superimposed for being printed or enlarged together.

Thick films easily cause loss of sharpness when sandwiched, because the emulsion planes may be positioned too far apart. During enlarging this effect can be minimized if not eliminated; but in contact printing under normal operating conditions it may be clearly noticeable. For this reason the copying procedure is slightly modified: instead of diffused illumination, the hard, focused light of the light cone from the enlarger lens is used for the exposure.

Negative and film are inserted in the printing frame as described previously, in which they are pressed closely together by the leaf springs of the closed frame. The frame is now placed on the baseboard of the enlarger, where it will be exposed to the light from the enlarging lens. This light is concentrated and projects, as it were, the negative at its full contour sharpness on to the film below. The exposure is slightly

extended, but this loss of a few seconds is immaterial compared with the gain in sharpness, especially if several superimposed negatives have to be printed on a film. This printing has also a secondary purpose. Logically, the result is a positive (transparency) ; it is harder than the negative, since both film and developer are designed for great contrast. Another printing stage produces a negative which, treated in the same way, is harder still. Sometimes several successive printings are required to achieve the desired extreme hardness.

Graphic-arts films are dearer to buy than bromide papers. You can avoid wastage of material if you set one sheet of film aside for trial exposures and cut it into a number of small pieces for this purpose. Under-exposure results in insufficient density (blackening) of the shadow portions, over-exposure blurs the sharp contours of the transparent portions. Neither effect is desirable. Exposure and developing time must therefore be determined as accurately as possible with the test strip to obtain a perfect print.

Finally a word about bromide papers. Of the range available, the hard or ultra-hard gradation is most suitable for your purposes. Glossy surfaces are best for copying. Matt papers, on the other hand, are particularly well suited to subsequent graphic or drawing work. Double weight base buckles less during this treatment than single weight. The papers used for copying documents, plans, and engineering drawings are therefore less suitable. Although they are very contrasty, the paper base is rather thin, and any area moistened with water will, after it has been worked on, form ugly "bumps" which are difficult to remove.

What else do you need? Something that can remove any undesirable or unimportant detail which draws attention away from the main subject. Two methods, suitable mainly for negatives, are available. (You can work on positives with black or white pigment, except that the original makes it difficult for the viewer to imagine the effect of the final picture.)

Opaque dye (or blocking-out fluid) is one medium that obliterates any unwanted detail that remains in the negative; it is available from artists' suppliers.

The other medium—also mainly used for negative treatment—is a bleaching solution, which removes all disturbing detail in the transparent portions of the negative. It consists of a 25% solution of copper chloride mixed with an equal volume of a 15% solution of sodium bromide in water. It is applied with a water-colour brush in the areas that need to be treated until the negative image becomes a cheesy yellow (the brown-green discoloration produced during the process can be disregarded). The film is then returned to the fixing bath, where the reduced details are dissolved, leaving com-

pletely clear film in those places. The film must now be washed, as usual, to eliminate the fixing solution before it is hung up to dry. Naturally, any black portions can also be completely removed from a positive without any application of dye.

# Index